for Morris Engel –
with love

Louis Stettner

"I am a street photographer and have from boyhood obsessively photographed the people, events and light of everyday life. The ordinary has always seemed enough of a miracle. . . I try to learn enough art, compassion and laughter to stop time occasionally — to manifest on photographic paper a few ordinary miracles."

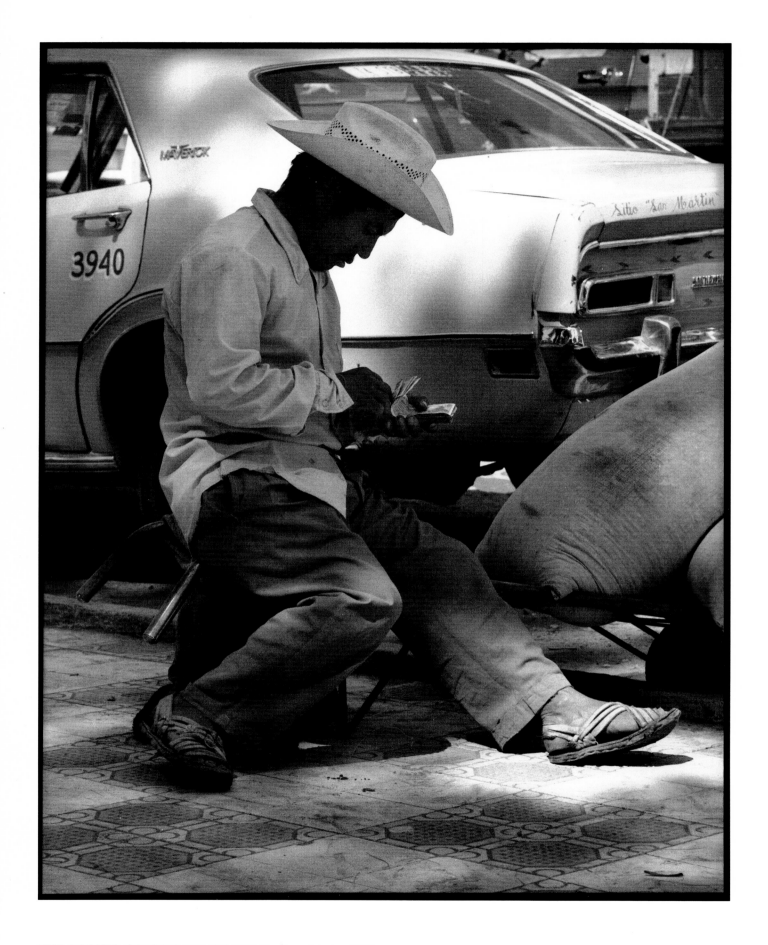

THE PORTER COUNTS HIS WAGES *Naolinco, Mexico 1979*

ORDINARY MIRACLES

The Photography of LOU STOUMEN

Photographs and Text by Lou Stoumen

Introduction by William A. Ewing

ALLENTOWN ART MUSEUM
Allentown, Pennsylvania

FREDERICK S. WIGHT ART GALLERY
University of California, Los Angeles

INTERNATIONAL CENTER
OF PHOTOGRAPHY
New York

ORDINARY MIRACLES The Photography of Lou Stoumen.
A traveling exhibition based on this book originated
January 18, 1981 at Allentown Art Museum, Richard N. Gregg,
Director, under a grant from Pennsylvania Council on the Arts.

The exhibition was also scheduled for the Frederick S. Wight
Art Gallery UCLA (Jack Carter, Director), International
Center of Photography (Cornell Capa, Director) and
other institutions during 1981, 1982 and 1983.
Peter Blume curated for Allentown. William A. Ewing,
Director of Exhibitions at ICP, guest-curated the show
and wrote the Introduction.

This book was designed by its author at Hand Press,
Los Angeles, and set in Goudy types at Hamilton
Composition, Los Angeles. It was printed at Gardner/Fulmer
Lithograph, Buena Park. The photographs are reproduced
in black-and-gray duotone from laser scanned plates.

Library of Congress Cataloging in Publication Data

Stoumen, Lou
 Ordinary miracles
 "A Hand Press book"
 1. Photography, Artistic — Exhibitions. I Title.
TR647.S845 1981 779'.092'4 80-28868

Manufactured in the United States of America.

CONTENTS

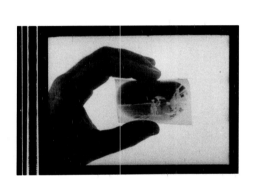

ALLENTOWN ART MUSEUM
Allentown, Pennsylvania
January 18, 1981 — March 1, 1981

FREDERICK S. WIGHT ART GALLERY
University of California, Los Angeles
November 22, 1981 — January 10, 1982

INTERNATIONAL CENTER OF PHOTOGRAPHY
New York
April 1982 — May 1982

INTRODUCTION *by William A. Ewing*

I

Lou Stoumen is a man in the prime of life. In terms of his age, 63 at the date of this publication, we might rightfully expect to see a complete retrospective of his life's work. But how "complete" can a retrospective be for an artist who hasn't entertained the remotest thoughts of retirement, for a man with more energy and ideas than ever, for an artist who can write to a friend, ". . . have experienced a sustained and unexplained surge of creative energies, am more prolific than ever. New work feels fresh, strong and headed in new directions. Have changed optics, chemistry, enlarger and sleep habits (less)."

With several photographic books and a novel in preparation, a *Forty Years* portfolio just completed, a major exhibition of his photographs traveling the country, self-assigned new photography projects in advanced stages of work, and his commitment as full-time professor at UCLA film school, the day we can offer Mr. Stoumen his complete retrospective is some number of years away.

This is a book of photographs based on the current Stoumen traveling exhibition, which I had the pleasure of guest-curating. To do so I interviewed Mr. Stoumen in depth, looked at all his some thousands of photographic prints and all of his negatives, including unprinted work some of which, at my request, he printed for the show and for this book. Of the 115 pictures in the exhibition, 69 appear here, reproduced in elegant laser-scan duotone.

But this book, however state-of-the-art technically, is not the usual exhibition catalogue (though a catalogue is appended, p. 99). Over the years Stoumen has paralleled his photographic development with intensive work as a creator of words. He has published poetry, fiction, war correspondence, criticism and screenplays. And he has written texts for his photographic books and portfolios that are unique to the extent of establishing a new form. He marries imagery with text in a truly poetical style that moves beyond explanation or description.

Stoumen's first "paper movie" (as he now calls the form) was a book of 50 photographs and 12 poems, *Speech For The Young*, published when he was still an undergraduate at Lehigh University in 1939. His later paper movies include *Yank's Magic Carpet* 1945, *Can't Argue With Sunrise* 1975, *Times Square* 1940 (1977), *Forty Years* 1980, and *Ordinary Miracles* 1981.

Some years ago Stoumen turned to films, a medium in which he was further able to engage his literary and visual skills, efforts that ultimately won him two Academy Awards and two major prizes at Venice Film Festival. Nevertheless, still photographs have (as a book of them has) some advantages. They can be held, studied, appraised at leisure, unlike the flickering illusions of the cinema. Less strident and propagandistic than cinematic imagery, still photographs are somehow a more personal medium. Perhaps because they are physical objects they appear closer to the intent of their originator. A book, it seems to me, is therefore the ideal format for Lou Stoumen's sensibility.

But whatever the "ideal" format, Lou Stoumen can lay claim (or we can lay claim for him) to be a photographer of considerable importance. His still evolving body of work is bold, original, and has the power to surprise. It is expressed in finely crafted prints.

II

Lou Stoumen took his first photographs in the 1930s with his mother's "vest-pocket Kodak." Forty-odd years of photography is a long time, in fact, a third of the entire history of the medium since its invention in 1839. It's not too surprising then that during his career Stoumen had personal contacts that shaped his growth with many of the influential figures in the field, most notably Alfred Steiglitz, Paul Strand and Edward Weston. Even Steichen was to have an influence; although the two men never met, they did correspond, and Steichen thought sufficiently of the younger photographer to include his work in three exhibitions at the Museum of Modern Art, including "The Family of Man." Steichen's successor John

Szarkowski has also exhibited Stoumen's work and purchased a number of prints for the Museum.

From an early enchantment with photography (he was only ten years old when he discovered how camera-vision could restructure the world) Stoumen has always maintained a strong affection for the traditions and history of the medium. In *The Naked Eye*, a feature-length documentary about photography, he paid homage to some of the photographers he admired: Nadar, Steiglitz, Eisenstadt, Bourke-White, Weegee. In a particularly lyrical and moving sequence he traces the career of Edward Weston. Although the film was produced some 25 years ago, it does not seem in the least dated. With Weston's death in 1958, *The Naked Eye* has become all the more important as a resource.

In another film made during the same period, *The True Story of the Civil War*, Stoumen again made extensive use of his knowledge of photographic history, drawing on the work of Matthew Brady and other Civil War photographers to construct an animated story of extraordinary visual and aural impact. This was accomplished not only through ingenious use of complex editorial techniques involving cuts, zooms and dissolves, but more significantly through use of exceptional still photographs, each selected as a work of art in its own right. With every image one of power, in combination with Stoumen's poetic narration (spoken by Raymond Massey), realistic sound effects and a musical score by Elmer Bernstein and Ernest Gold, a film of explosive impact, perfectly suited to the emotionally charged subject matter, was produced. It won Stoumen his first Academy Award in 1957 and also a First Prize at Venice Film Festival.

Several years later, Stoumen further developed the techniques of animating photographs he had pioneered. *Black Fox*, a feature-length documentary that won him his second Oscar, involved more ambitious story-telling than his earlier efforts. The film employed as an allegorical device the medieval Franco-German folk tale *Reynard The Fox* to tell the grim story of Adolf Hitler's rise to power and ultimate self-destruction. The concept called for an elaborate intercutting between drawings and photographs, plus a mix of actuality live action. What might easily have been a discordant muddle of media was transcended through a conceptual and technical deftness that blended all elements seamlessly. Words, sounds, music and pictures were paced to keep the story unfolding at an almost intolerable emotional level. Marlene Dietrich cried during her recording of the narration.

For *Black Fox* and other film work, Stoumen eventually won another prize. Today he is a full professor of motion pictures at UCLA film school. He teaches direction, screenwriting, and a course he designed, The Film Image, about the history and art of still photography as it relates to motion pictures.

III

Son of a country doctor and a music teacher in Springtown, Pennsylvania, Lou Stoumen was a sickly child, almost dead of pneumonia at age two. He tells with appreciation how, when he was in coma near death, the congregation of the Lutheran church next door held their church bell quiet for two Sundays.

In bed a great deal, encouraged by the literary bent of his mother, Lou Stoumen read books — Robert Louis Stevenson, Edgar Allan Poe and Grimm's Fairy Tales, all, he reports now, in illustrated editions. Health recovered, grown over six feet tall in high school, he was particularly enthralled with a book that happened to come to his mother through a book club, *America and Alfred Steiglitz,* which opened his eyes to the possibility of a career in photography. "At that point," recollects Stoumen, "I knew I was a photographer as well as a writer."

Just after the war Stoumen was able to visit Steiglitz' gallery, An American Place. A young married man living in Los Angeles and just out of uniform, Stoumen had much to attend to in New York and little time. Entering Steiglitz' gallery, he found on the walls a group show of several painters and a small exhibition of black and white nature photographs by Eliot Porter. There was not a single other visitor in the small gallery. Stoumen went at once to a Georgia O'Keefe painting, to a Charles Sheeler drawing, and then concentrated on the Porter photographs — mushrooms, birds, a forest floor with tree trunks.

From behind a curtain a frail whitehaired man approached. "I like the way you look at pictures," he said. Steiglitz and Stoumen talked for an hour. Steiglitz looked at some work the younger man had with him, to show to editors, and paused over

a surreal image Stoumen had accomplished through multiple exposure. Stoumen felt an embarrassment, observing that this picture was "not characteristic of my work." To his surprise, Steiglitz then pulled from a file a similar multiple exposure he had produced, close to Stoumen's in concept but marvelously executed. The younger man was humbled, and newly inspired. When Steiglitz tired, lying limp on a couch behind his curtain, Stoumen shook the master's hand a grateful goodbye. "It was a very tired old man's hand," Stoumen remembers. "I knew he didn't have much time left, in his empty gallery."

While Stoumen also credits Walker Evans and Ansel Adams with considerable effect on his development as craftsman and artist, he reserved a special place for two other photographers of disparate styles, and for that matter life-styles, Edward Weston and Sid Grossman. "I had first seen Weston's work in the 1946 exhibition at the Museum of Modern Art where I went as often as I could," explained Stoumen. "Back in Los Angeles, Edward's oldest son Chandler was my friend. I asked if he'd set up a meeting with his father, and one day in 1947 I found myself, portfolio in hand, at the door of Edward Weston's wooden cabin in the Carmel highlands. He lived most simply, and worked with simplicity. That impressed me. I visited often after that and we corresponded. He was very encouraging about my work, which was so different from his, and at my request he would always show me 20 or 30 of his own prints, himself placing them one by one on an easel under his studio skylight. My then wife and I named our daughter Tina after Edward's great love, Tina Modotti. In 1956, with the help of Brett Weston and Dody Weston, I made what is probably (with Willard Van Dyke's *The Photographer*) the definitive film about EW and his life's work, *The Naked Eye*. The film premiered at a theater in Carmel. Edward was in the audience, his last public appearance. He cried."

Stoumen's relationship with Sid Grossman was somewhat different. Grossman was, by all accounts, a fine teacher, a considerable photographer, and a difficult person. The role he chose to play with Stoumen was not that of a mentor. There were unpleasant competitive moments at the Photo League, where Stoumen had enrolled in Grossman's six weeks course in basic photography. Grossman was an avowed Marxist, and while Stoumen shared the social concerns of the 1930s

SIX FRAMES FROM "THE NAKED EYE" 1956 *Blind Woman by Paul Strand. Weegee photographs in Times Square. Tina Modotti recites poetry (photo by Edward Weston). Edward and Brett Weston confer over a print. Edward Weston shoots in the Sierras (photo by Ansel Adams). Nahui Olin and Dr. Atl (montage) by Edward Weston.*

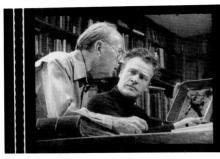

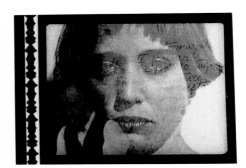
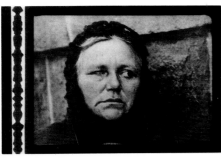
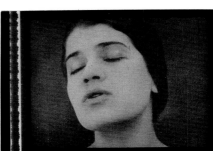
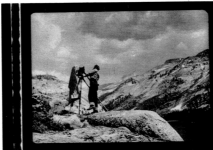

he refused to become doctrinaire. Teacher and student argued bitterly.

The rift came over Grossman's rejection of his student's self-assigned photography of Times Square as "not socially significant." Better, Grossman insisted, he should work in Harlem or the lower east side. But for Stoumen, a country boy, Times Square was the center of the world (see pages 22-23). That magical crossroads so captured young Stoumen's imagination that in 1979 he was back in the Square, still photographing it 40 years later (pgs. 46-52), preparing a new book under the working title *Times Square/Changes.*

Nonetheless, Stoumen credits Grossman with important lessons: he taught absolute respect for the equipment, materials and practice of the profession. "Grossman was absolutely dedicated," Stoumen remembers, "and he communicated that passion to many students. He gave us an almost religious sense of the power of really believing, with no thought of the marketplace, in the worthwhileness of photographic work."

IV

It might seem that Lou Stoumen has spread himself too thin to achieve an historically important body of photographic work. He spent years of his life as soldier, writer, editor, director, producer, professor. He's also been a parcel post "thrower" at Los Angeles post office, a tree climber for the Department of Agriculture in Pennsylvania, a snow laborer for the city of New York. He's visited Brazil, north and south Africa, spent three years in the Caribbean islands, traveled Alaska by light plane and dogsled, crossed India by train, and spent time in the interior of Burma and China. He edited several magazines, paid dues in photography doing product shots, weddings, babies and quantity printing in a commercial photo lab, and flew as war correspondent on the first B-29 raid against Japan.

But perhaps it's precisely this adventurous mix of life experience that gives Stoumen's work its uniqueness and appeal. Wherever he's been, the camera has been constant companion. He photographed, as he says, "obsessively." There were no major grants, no *Life* magazine assignments, no remunerative annual reports. The result has been that for the most part Stoumen's pictures were not subject to the subtle compromises required by clients, publication deadlines and high-income standard of living. Stoumen's pictures were made for himself, and now for us.

His pictures have about them a special humor and directness — and what might be called a compassionate detachment. Stoumen wrote in *Can't Argue With Sunrise* that when he served in the US Army during the Second World War he felt he was "God's spy among the soldiers", his photographs "my report from that mission."

Unlike most photographers, Stoumen is not easily classifiable. His pictures *are* ordinary, or at least of ordinary subjects, but sometimes his treatment of the usual is successfully surreal, or lyric, or full of paradox. He calls himself a street photographer, and shoots the Taj Mahal from an airplane. He's an east coast photographer who lives and works in California. He is not a combat photographer, a documentarian, a maker of land-scapes, a conceptual artist, a celebrity portraitist, though he has done all these things.

Unspecialized and thus uncommercial, Stoumen is — a generalist, beholden to no particular style, esthetic or genre. He has always sought the shifting vantage point. His images, at least the best of them, speak to us with a disarming simplicity that is uncommon. Individual photographs like *Times Square In the Rain* (pg. 23), *Black Cat Bar* (32), *Bombing Mission, China* (39), *Ranchos de Taos Church* (71), *The Lovers* (93), *Girl With Fish* (not in this book) and *The Porter Counts His Wages* (frontispiece) resonate in the mind with old-master clarity.

It may be after all, as the import of his prolific and varied work continues to mount, as the later photographs take on some of the classic patina already achieved by the early Times Square pictures, that Lou Stoumen's body of work will emerge from the mass of contemporary photography as one of the more memorable records and cele-brations of our century.

HOME TOWN (1932-1939)

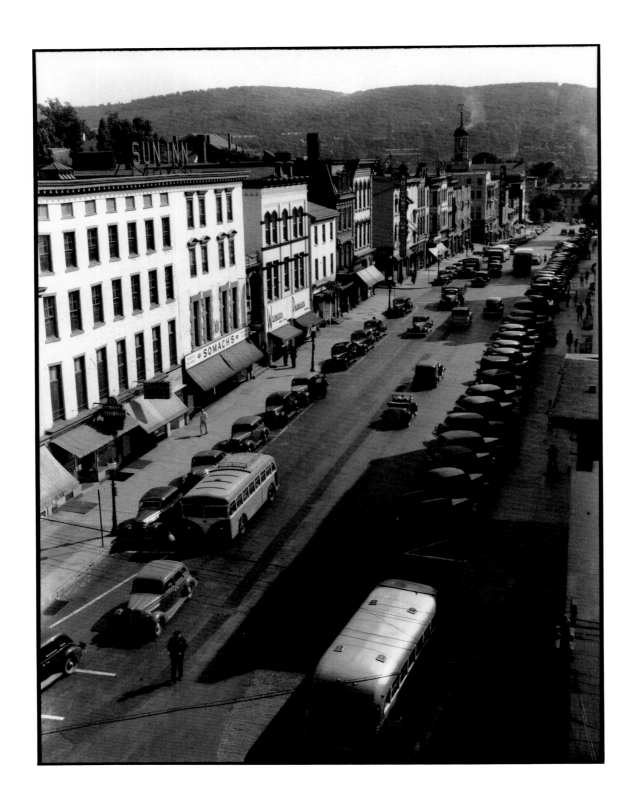

MAIN STREET *Bethlehem, Pa. 1939*

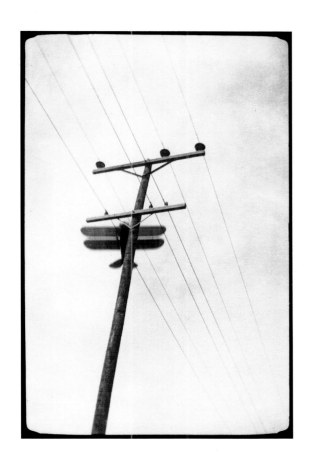

AIRPLANE AND TELEPHONE POLE *1932*

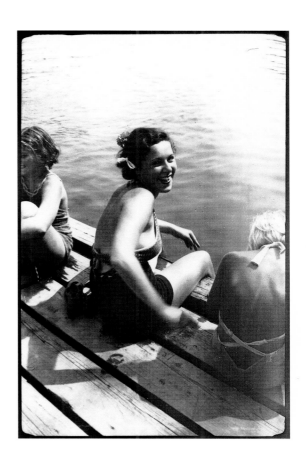

GIRL ON PIER *Saylor's Lake 1934*

MY FEET AND SHOES *Saylor's Lake 1935*

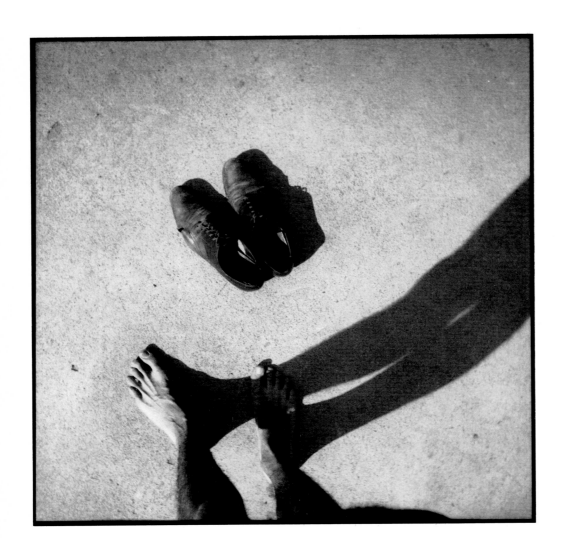

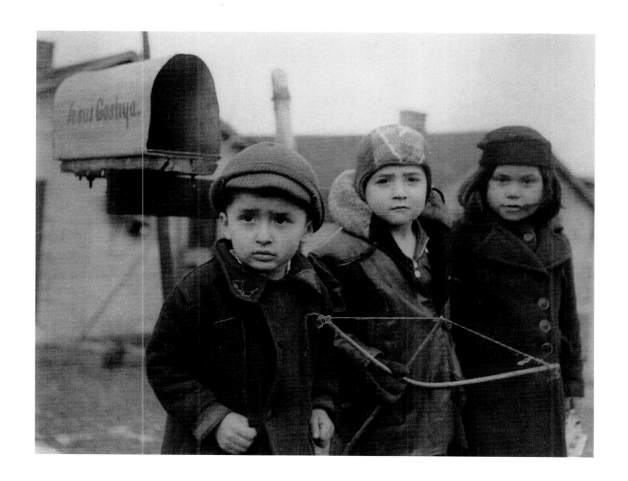

THE CHILDREN OF JESUS GOSHYA *Hellertown 1937*

Those days before TV hypnotized whole generations, we children depended on ourselves for fun. We invented games, made our own toys. Scooters out of old roller skates nailed to boards. Snow toboggans from packing boxes. Secret club houses in trees. Telephones out of tin cans and waxed string. Kites, crayon drawings, handmade bows and arrows.

I made this photograph on a cold winter's day down by the Coke Works, which was part of Bethlehem Steel Company. The area smelled of burning sulphur. Little cars on rails dumped hot slag down a hillside (making spectacular lava flows at night).

It was a great place for us kids to live, and to leave when we grew up.

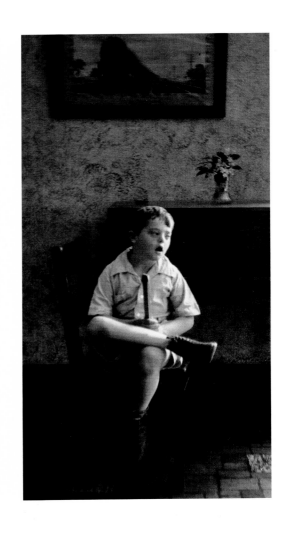

RETARDED BOY *1937*

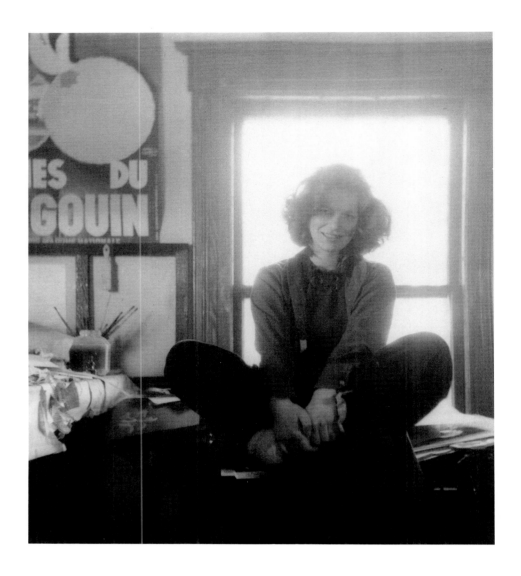

MARION SCOTT IN HER STUDIO *Brooklyn 1937*

I rode in from Pennsylvania on the train to visit her. At 17, Marion was already an Artist, with her own studio (though in her parent's home). We went to the Museum of Modern Art. She introduced me to an odd new Italian food that was fun to eat because it dripped cheese when you lifted it to your mouth, she called it pizza.

Marion was a painter and sculptor. We were mutually admiring friends for a while. She liked my photographs, especially those of herself. I loved her, I thought. She wouldn't even let me kiss her.

This photograph of Marion was the first "portrait" I ever made that I liked. The negative is lost and this reproduction was made from the only print. Marion sits there on her worktable forever.

15

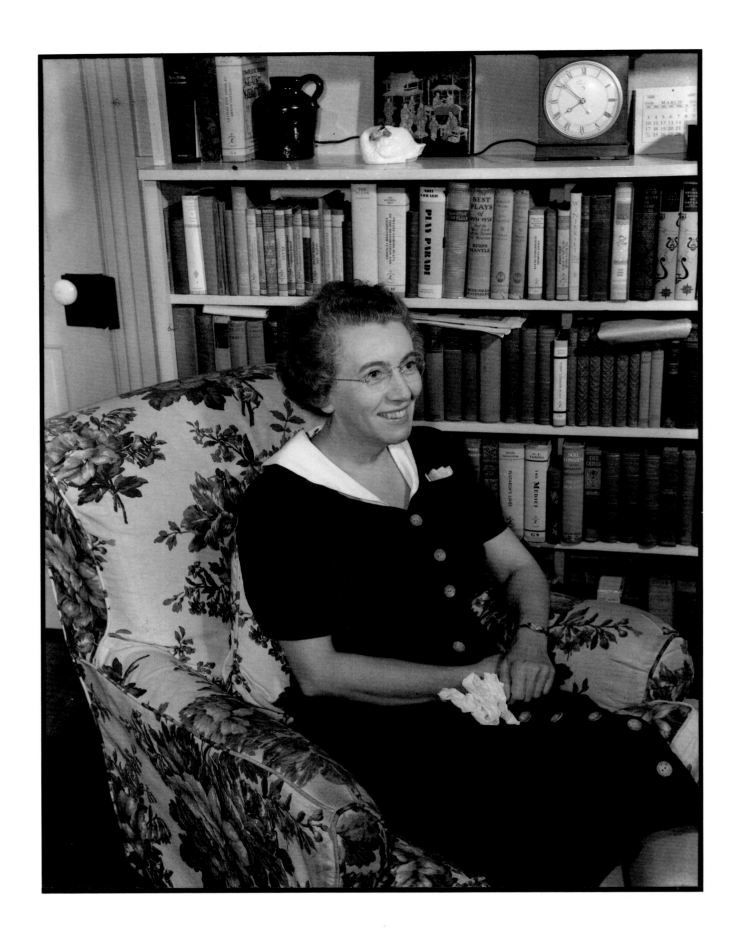

MISS NELLIE BUSTIN *Bethlehem 1939*

When I was a student at Liberty High School my English teacher Nellie Bustin was already old, probably past 40. I wonder if she's still living? I'd like to show her this book.

I had a crush on Miss Bustin. She invited me to her house for tea, cookies and criticism of my photographs and writing. That was the first serious attention my work had.

I liked being with Miss Bustin, and photographed her, and one day it occurred to me, hey, she's pretty old but she's alone. Maybe she'd be happy, well, to have a young lover.

That thought lasted about two days. Then I had to admit there were a dozen young girls at Liberty High I'd rather be lovers with than old Miss Bustin. Besides, if I tried, she'd probably laugh at me, or be angry, and I'd lose her friendship instead of my virginity.

I did once move toward the subject. I dared ask how come she'd never married. *"Oh,"* Miss Bustin said, and she blushed. Her voice changed. *"I had a beau once. We were all set to marry. He was killed in France in 1917."*

NEW YORK CITY (1940)

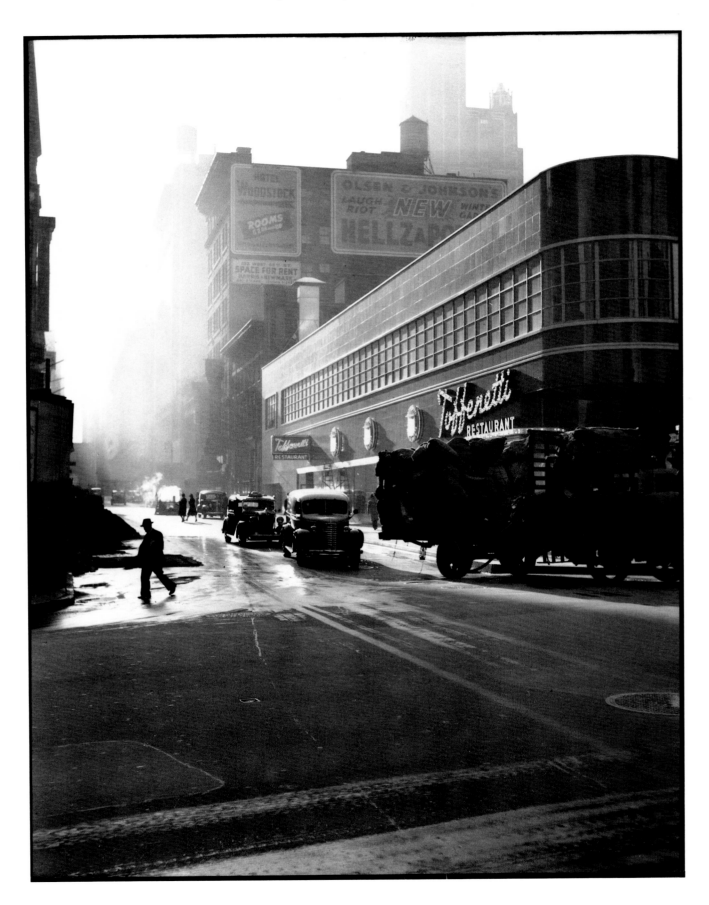

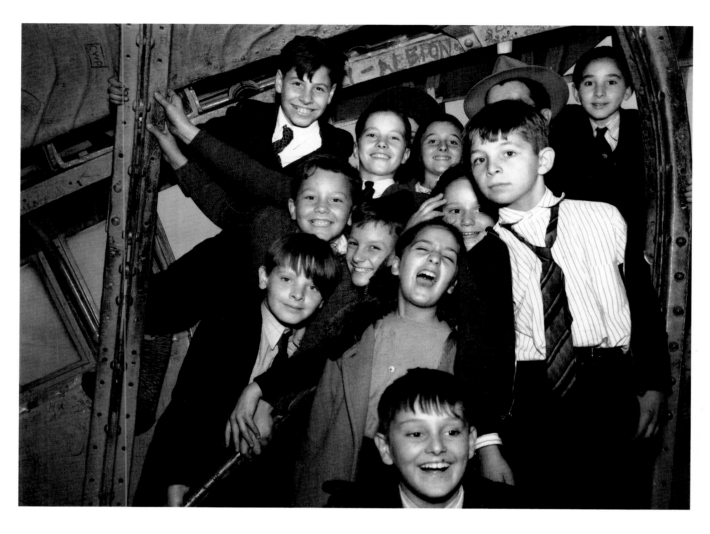

CHILDREN OF PUBLIC SCHOOL #34, THE BRONX, INSIDE HEAD OF STATUE OF LIBERTY

SUNRISE *43rd Street at Times Square (homage to Alfred Steiglitz)*

Shabby unsmiling unemployed men (seldom a woman) used to come knocking on the back door of our house in Pennsylvania and ask mother if she had some work she wanted done.

Mother would always say, *"Why no, thank you, not right now. But maybe you'd like something to eat?"*

He'd usually allow as, *"Yes, Ma'am, I'd appreciate that."* She'd set him down at the kitchen table to whatever there was, milk, a couple of eggs, or a grilled cheese sandwich, or a helping of our family dinner cooking on the stove (which got to be serious if there were only so many corn ears or chops).

Mother wasn't unique. The housewives of our country probably fed more strangers those Depression years then the restaurants and soup kitchens combined.

I made this photograph of unemployed men warming themselves at a packing-box fire in New York City in 1940. The billboard was part of a campaign by the National Association of Manufacturers. The business leaders needn't have worried. Unemployment, Depression and bankruptcies were almost finished by 1940, solved by a great new growth industry, World War Two.

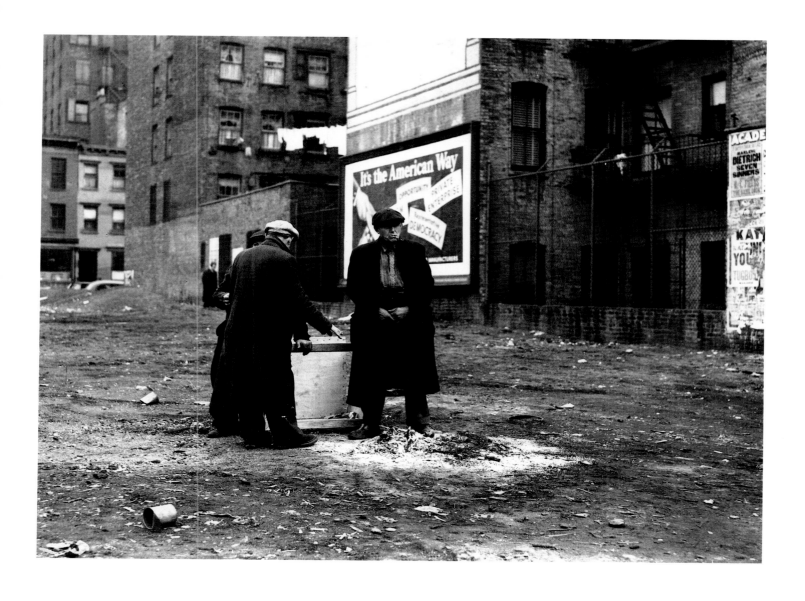

UNEMPLOYED MEN

Maybe the magic is gone now, along with Hotel Astor and the proud sign of the New York Times. Those days Manhattan was the center of the world, and Times Square was its heart.

Albert Einstein walked the Square those days, and Joe Louis, Benny Goodman, Alfred Stieglitz, Ella Fitzgerald, Carl Sandburg, Robert Capa, Sylvia Sydney (I love her still!) and Arturo Toscannini.

The Times Building elevator went up 19 floors. I walked the rest, up to the roof ledge overhanging the great Times sign. It was starting to rain. I leaned out, camera finder to my eye, and waited — till the rain wet down the taxis and the people and turned the great X of Broadway and Seventh Avenue into silvery rivers.

This is my thank-you portrait of Times Square.

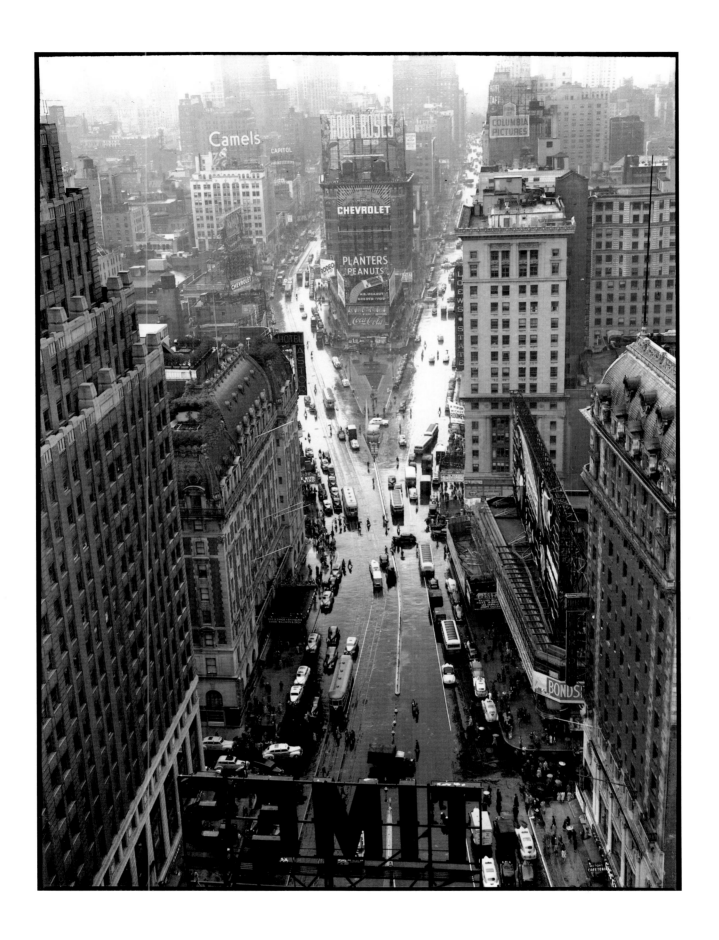

TIMES SQUARE IN THE RAIN

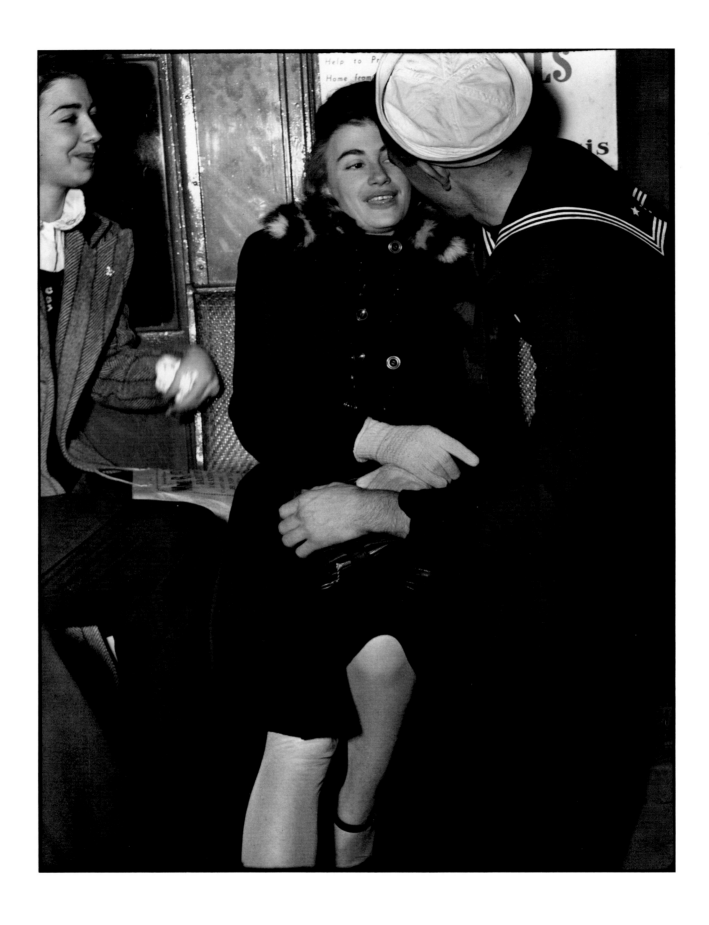

SAILOR AND GIRL *Subway*

It's sometimes necessary to shoot from the hip, like an ambushed gunfighter. It happens fast. You guess the distance, the angle, and you shoot.

I saw the possibility of this photograph aboard a subway train under Times Square and shot immediately, from my hip. If I'd raised the camera to my eye the sailor and his girl would have reacted, with anger perhaps or laughter. But then this moment of amorous electricity between them would have been lost forever.

PUERTO RICO (1941-1942)

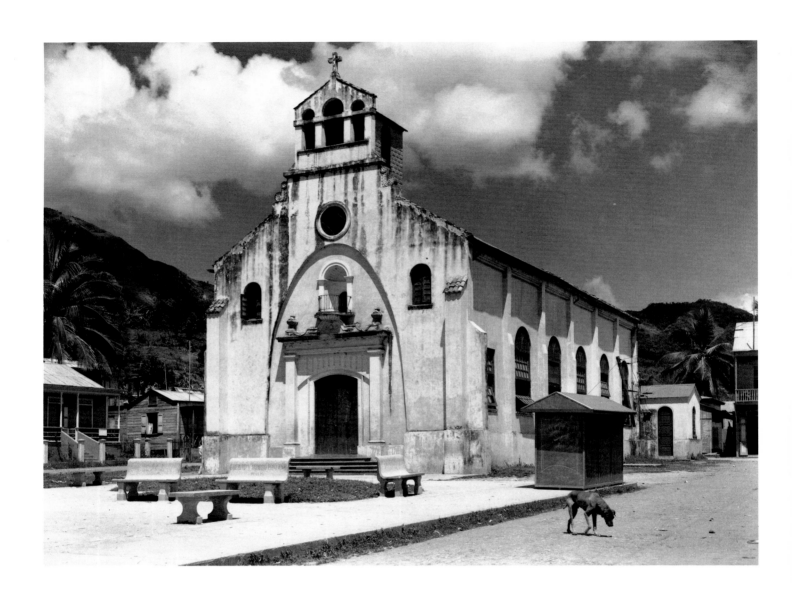

THE PLAZA, NOON *Jayuya*

CHILD'S COFFIN

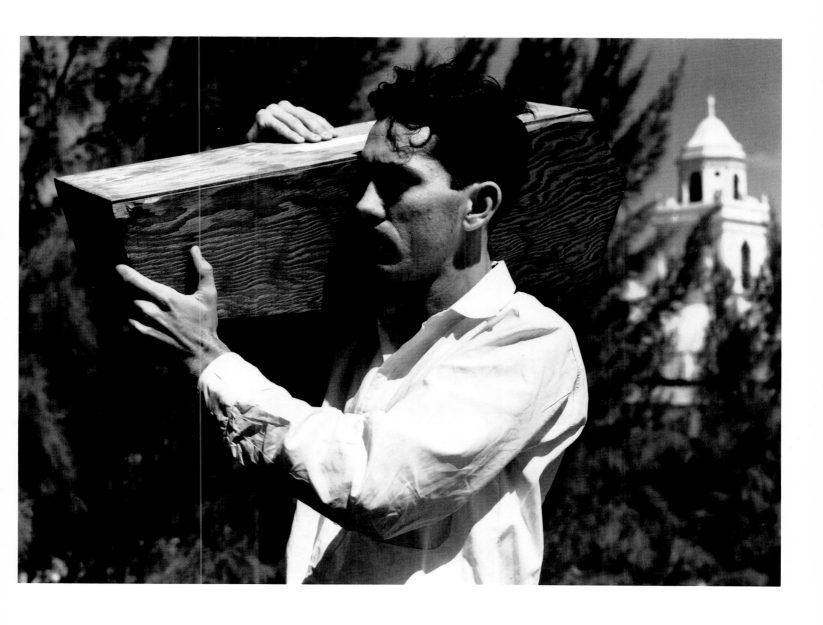

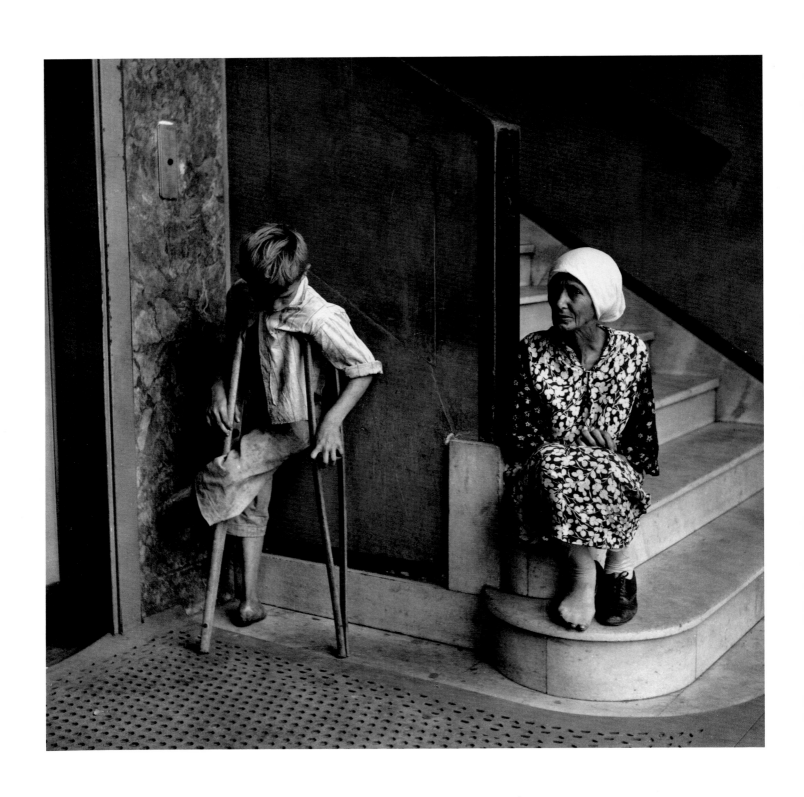

CRIPPLED BOY AND ONE-SHOE WOMAN WAIT FOR ELEVATOR

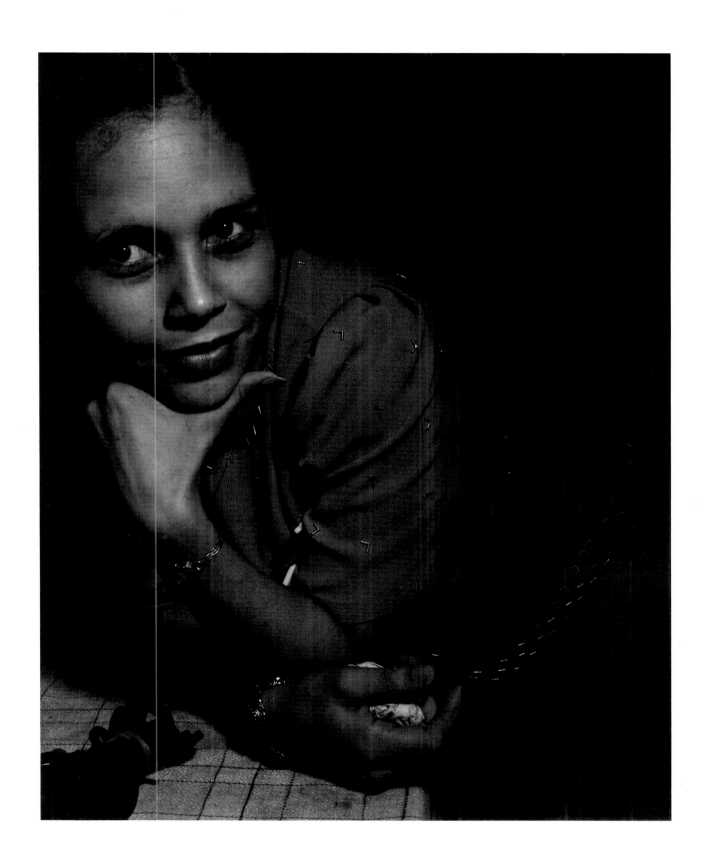

WOMAN FOR HIRE

My business was not in that ward, I was only passing through. But her face caught me as the moon catches tide. I approached her bed. *"Buenas dias, senorita,"* I said. She turned her face to the wall.

I couldn't leave. I read her chart. Amoebic dysentery. Bold, when the ward nurse wasn't watching, I touched the back of her hand there on the sheet. She turned her great eyes on mine, surprised. *"Me llamo Luis,"* I said. *"My name is Louis."*

Her lips opened. *"Lydia,"* she whispered. Then her fingers moved, surprising me. Her fingers were cool and weightless. They took my stranger's hand like a child accepting guidance across a street. We enjoyed a silence.

"Un retrato?" I asked, showing the camera. There was a gentle movement of her breath. *"Esta bien."* *"It's alright."*

Two days later I came by to give Lydia the photograph. Her bed was empty. *"Probrecita,"* the nurse said. *"Ella murio anoche."* *"She died during the night."*

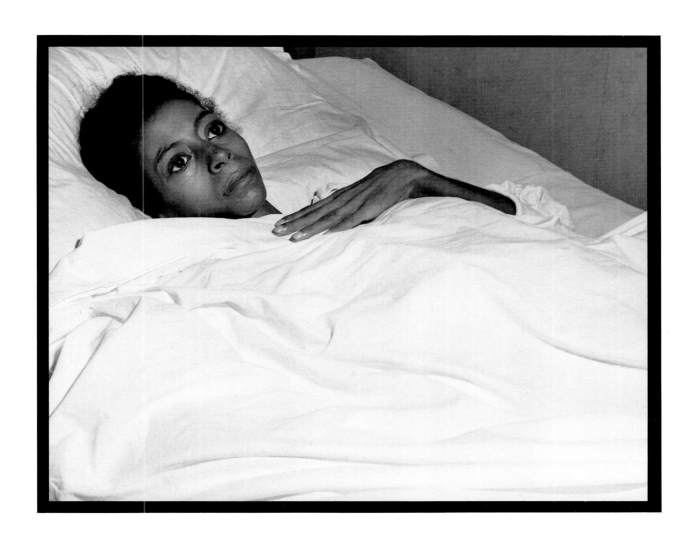

DYING GIRL

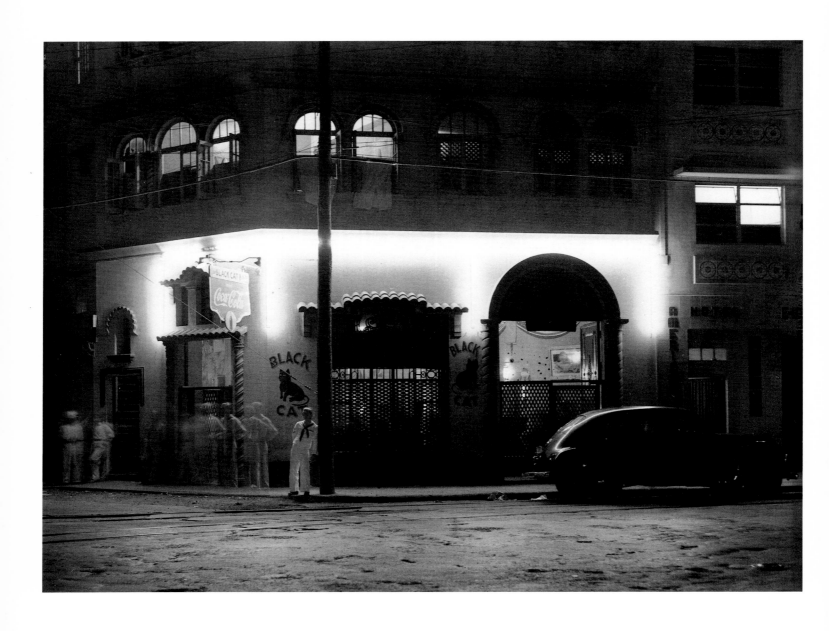

BLACK CAT BAR AND BROTHEL

In San Juan the public women were spirited teenage girls from poor villages. They sent money home to mamacita and the kid brothers and sisters. They liked the fun and confidence of the Yankee boys, and their money.

On the waterfront alongside docked ships the Black Cat did business. Soldiers, sailors and a few civilian workers would amble in for a beer or a rum-and-Coca Cola. They'd check out the girls, dance with one, buy her a drink, make the deal, and walk with her upstairs to one of the rooms on the second floor with a view of the sea.

My film and lens were slow those days. This photograph is a time exposure. I set the camera on a tripod and exposed for maybe eight seconds. The sailor stood firm. The soldiers moved about, their transient images adding a truth and strangeness to the picture.

TIME OF WAR (1942-1945)

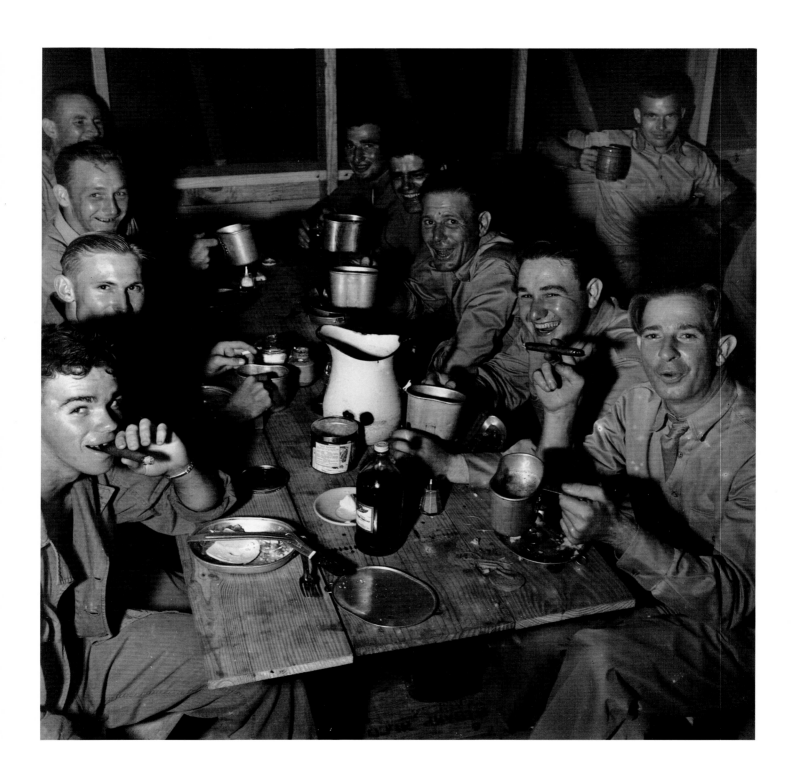

BEER AND CIGARS, THANKSGIVING DINNER *Camp Tortuguero, P.R. (negative damaged by fungus)*

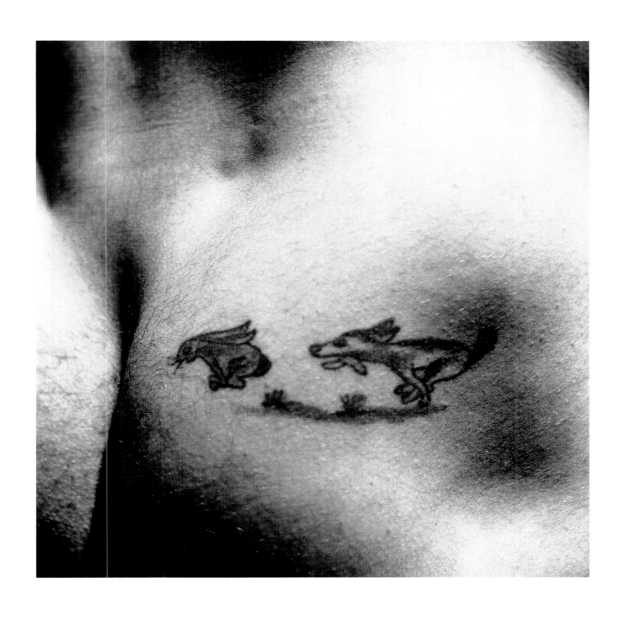

TATTOO, ABOARD US MISSION BAY *South Atlantic 1943*

ADOLF HITLER AND BENITO MUSSOLINI *North Africa 1944*

My first visit was by moonlight. Domes and minarets shone silver in the night. A turbaned Sikh led the way inside, his smoking lantern projecting mythic shadows across high marble halls. For extra rupees the old man sold me handfulls of flower petals to drop on the jeweled twin sarcophagi of Shah Jahan and his Queen.

Another time, when this photograph was made, I came to the Taj in a military aircraft. United States and Great Britain still owned India. We did as we pleased. My pilot flew low dangerous banks around the great building for my convenience.

I didn't know there was a river behind the Taj, the standard pictures don't show that. And how huge it is! Those tiny dots below the walls are people.

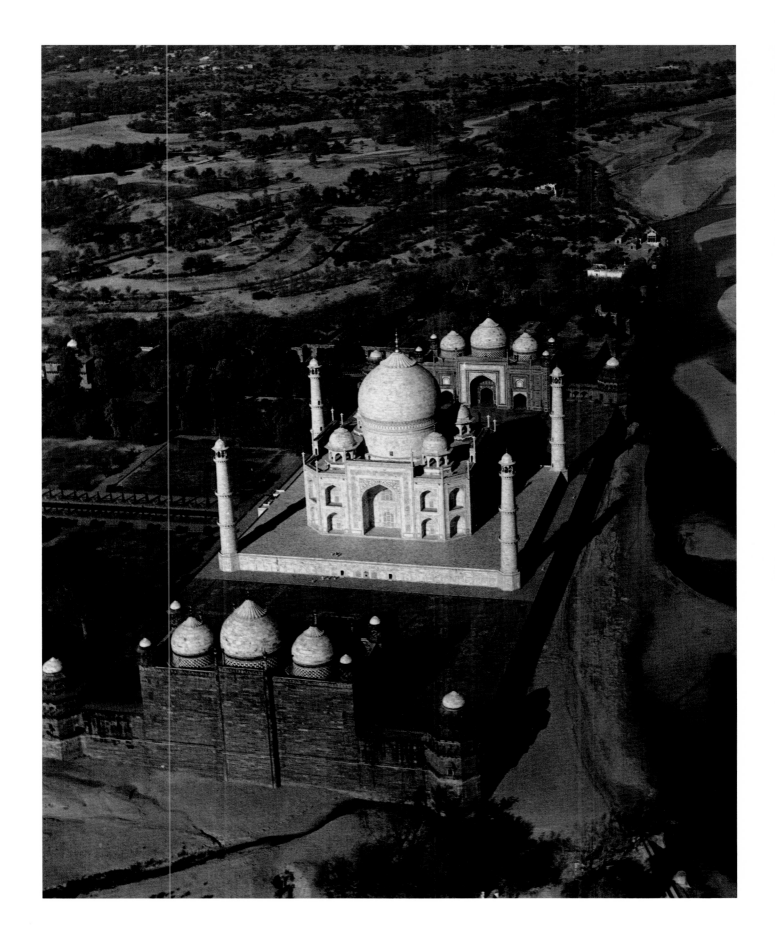

THE TAJ MAHAL FROM THE AIR *Agra 1944*

We dropped our bombs on the docks and railroad yards of Japanese-occupied Yochow, in China, and fought our way out among the attacking Zeros. Our B-24 cabin smelled of sweat, fear and our guns firing. I saw two of the Japanese flyers arc down in flames just like the movies.

This photograph is paradoxical. It looks serene but shrapnel flowers burst around our planes from enemy ground guns. We're under attack by Zeros.

A hurt Zero at this instant flys through our three-plane formation on a collision course. That's what I try to photograph, eye stuck to viewfinder. I fail to catch the action.

Scared, reflexes too slow, I see everything in dreamlike clarity. The elevated tail and waist guns of the B-24 off our wing, firing. The flight of three tiny B-24s far down at seven o'clock. The close tomato insignia of the Zero strobing past our cockpit window. Our pilot's sudden white knuckles on his wheel.

Later, safe at Kunming base, looking at the *photograph*, I see for the first time how the great thunderhead cloud seems to be an impossibly huge bomb blast.

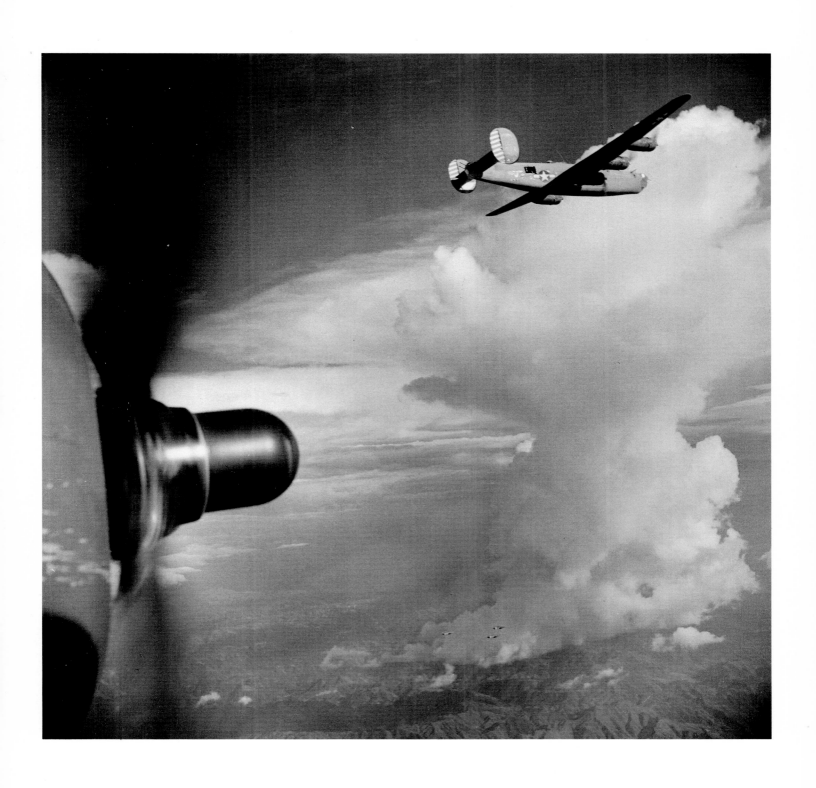

US B-24 LIBERATORS ON BOMBING MISSION OVER JAPANESE-OCCUPIED CHINA *1944*

In golden light of afternoon I flew from deep in China on the first B-29 raid against Japan. It was a thirteen-hour night mission. Target was the Imperial Iron and Steel Works at Yawata on the islandof Kyushu. We lost six planes, seven men in each.

Those who returned to base at Chengtu were told by intelligence officers we had destroyed 20% of Japanese steel-making capacity. That's what the radio boasted and the press at home headlined, including the cover story I wrote for *Yank, the Army Weekly*.

I learned after the war that most of our bombs that night missed the target. They fell instead on the thinwalled homes of civilians. There was a small fire storm. This was thirteen months before Hiroshima.

I mean to visit Yawata again. On the ground. I'll bow my head for them and for us, and place flowers.

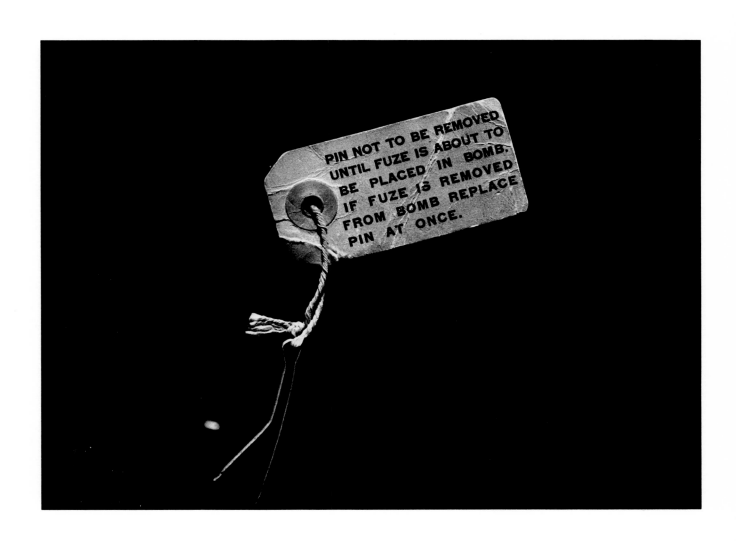

BOMB PIN *China 1944*

Now the experience of China seems like a
dream. I look at my old photographs like any
snapshooting tourist. They prove I was there.

The truth is I wasn't there wholly. My head
and heart were often Stateside. A soldier in a
far land full of war, I was the whole time afraid
of getting killed. Friends kept dying.

I learned that if you keep working, your
camera filters out the fear, reminds you of
objective reality.

The wise old man in this photograph will
always be my teacher and friend. The boy
soldier will be my comrade in arms. We're
closer now than we were then, language and a
camera between us. I clearly remember their
city Chengtu in the foothills of Tibet — a
medieval walled city full of trade, work, street
cries, odors, corruption and hope.

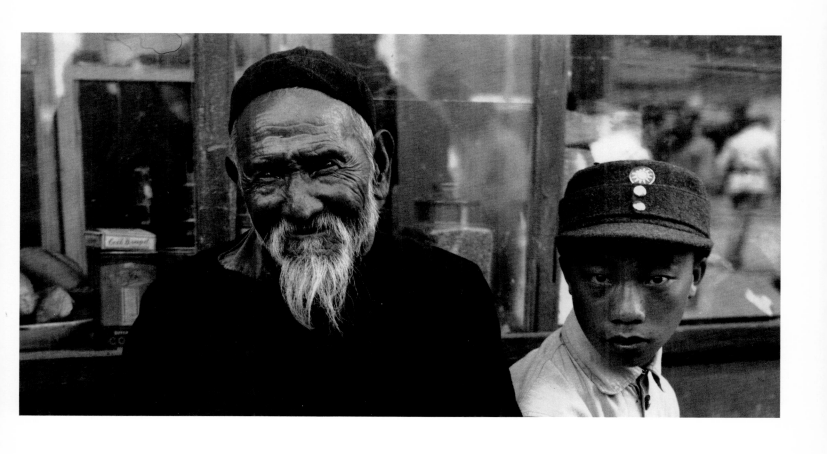

BOY SOLDIER AND GRANDFATHER *Chengtu, China 1944*

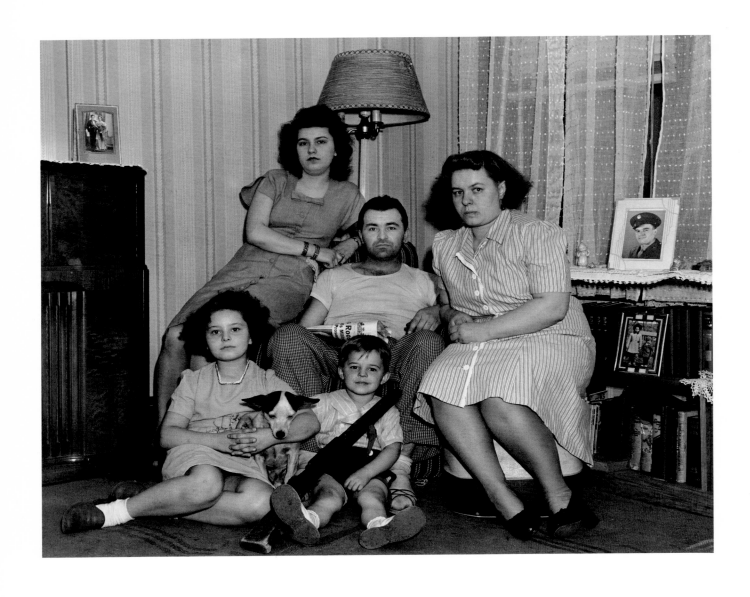

FAMILY, THE DAY FDR DIED *Chester, Pennsylvania 1945*

The last generally loved president of the
United States was probably Franklin Delano
Roosevelt. He'd been ill when he planned the
peace with Churchill and Stalin at Yalta, the
war not yet over. Then he died, a stroke.
Everybody felt bereaved that day. It was worse
than John Kennedy's death. Maybe like Lincoln's.

FDR had pulled us through the Depression,
made jobs for young people, helped the poor,
the blacks, the old. A rich aristocrat, he'd
disciplined the bankers and brokers till they
called him traitor to his class. Of course he'd
promised to keep us out of the European war.
But considering Hitler and Pearl Harbor, most
of us forgave him that.

I photographed this one family in Chester,
Pennsylvania. They all, even their dog, seem
heavy with loss.

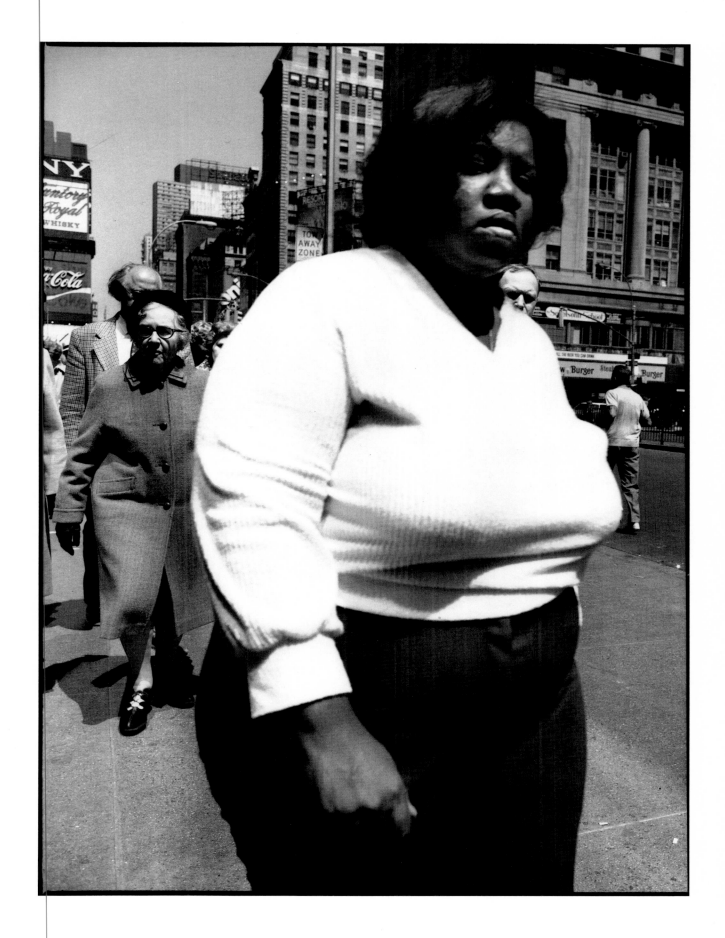

BIG WOMAN, TIMES SQUARE

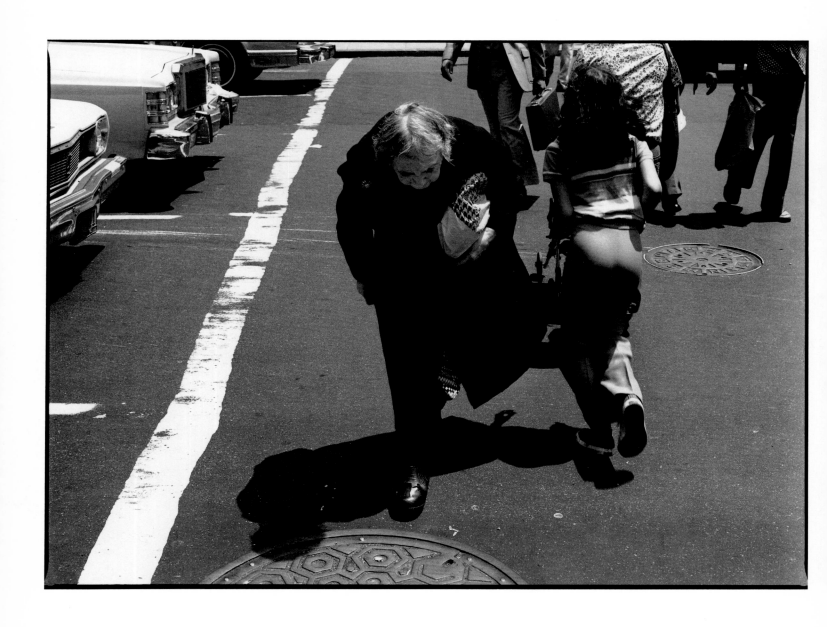

STREET CROSSING, THE GENERATIONS

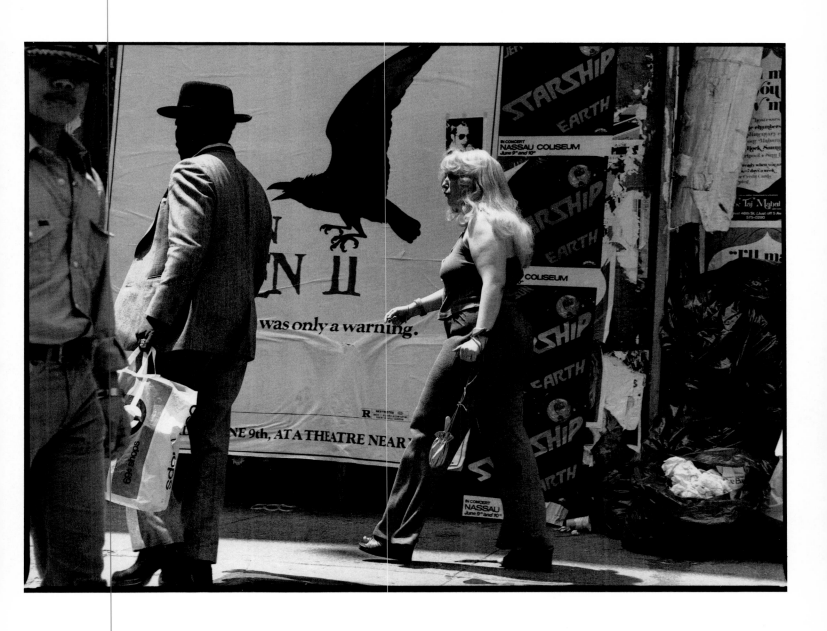

BLACK CROW, 43rd STREET

It's magical and tender how people, animals and plants manifest troubles in their appearance. We have no real secrets from each other. A drooping brown-tipped leaf tells all.

I saw this special moment of relationship in a young couple crossing a street. I chose the flashing moment of her *look* to make the photograph.

A conflict, a decision seems in progress. Her gaze is full of concern, perhaps reproach. What could be the reason?

The young man's melancholy is also plain to see. Does he desperately wish to be somewhere else, alone?

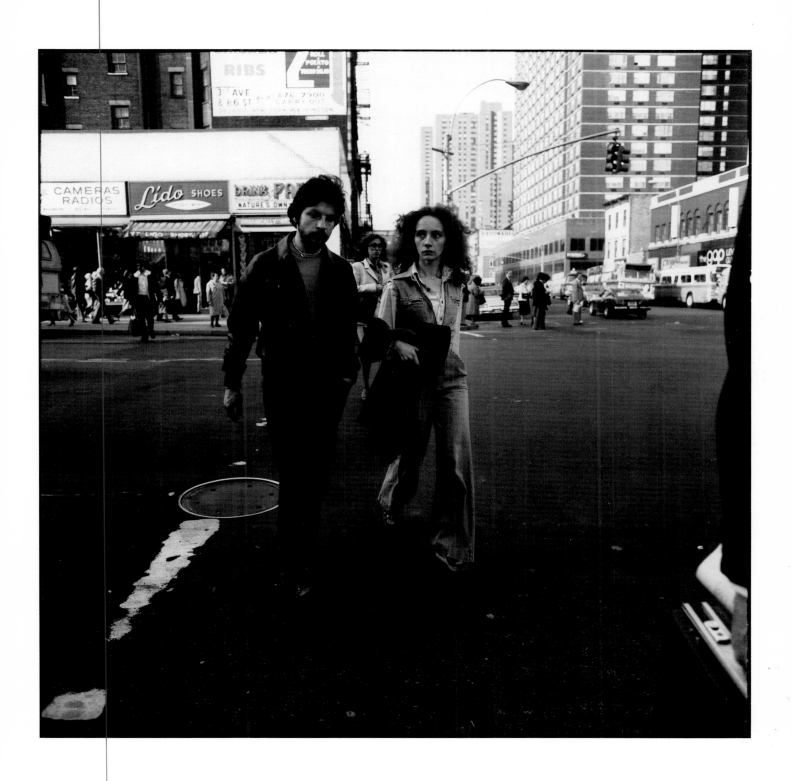

THE LOOK, 86th STREET

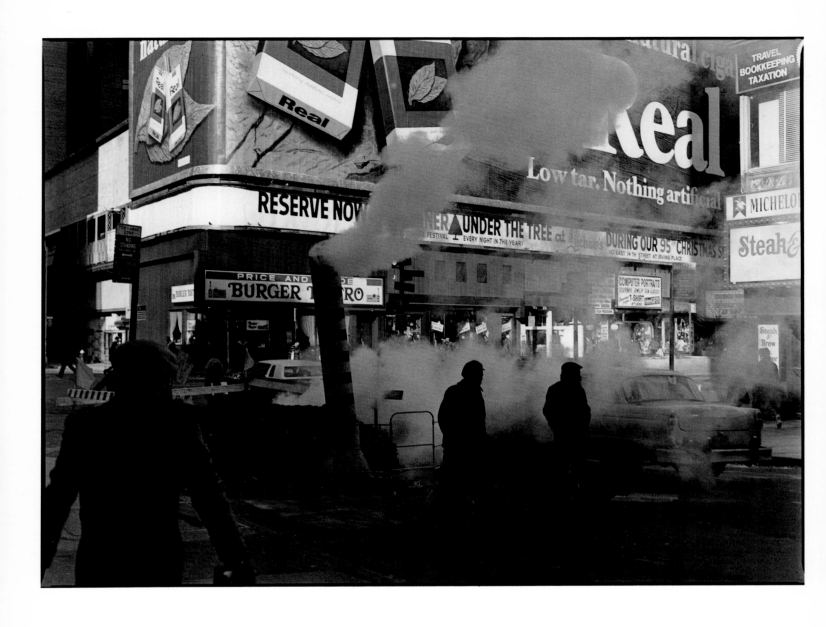

SUNSET, TIMES SQUARE

52

THE WEST & THE LOS ANGELES SCENE (1947-1980)

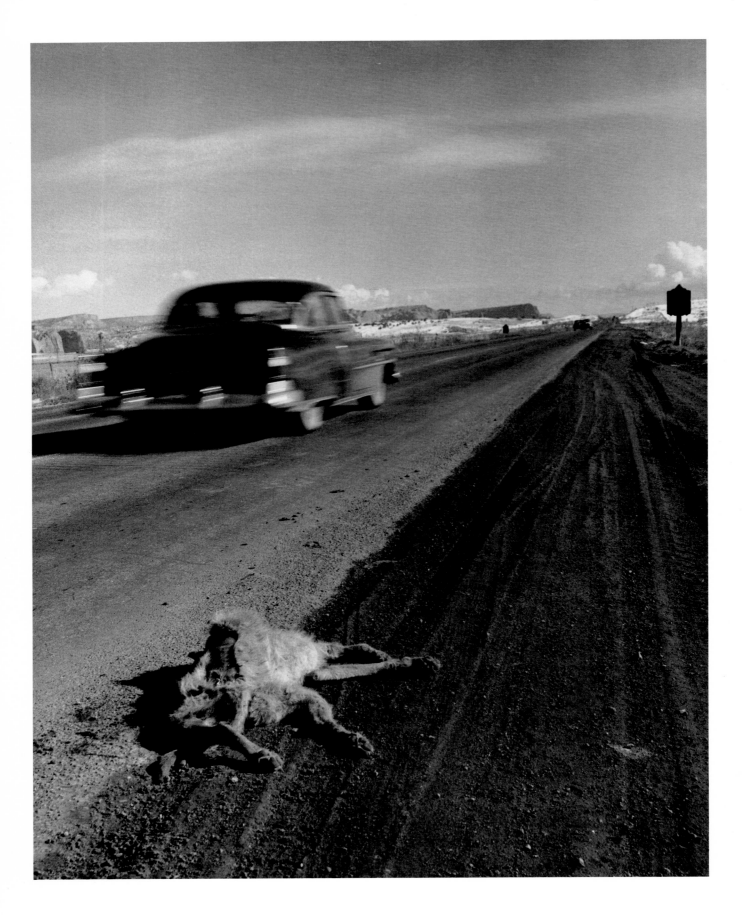

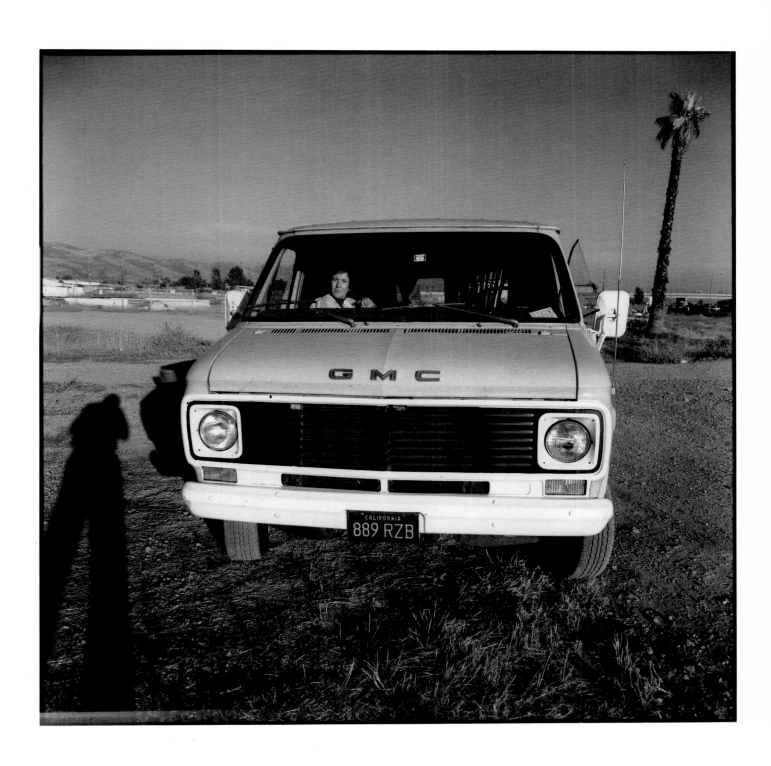

GMC, US 101 NEAR SAN JOSE *1979*

ANIMAL DOWN *US 66 1949*

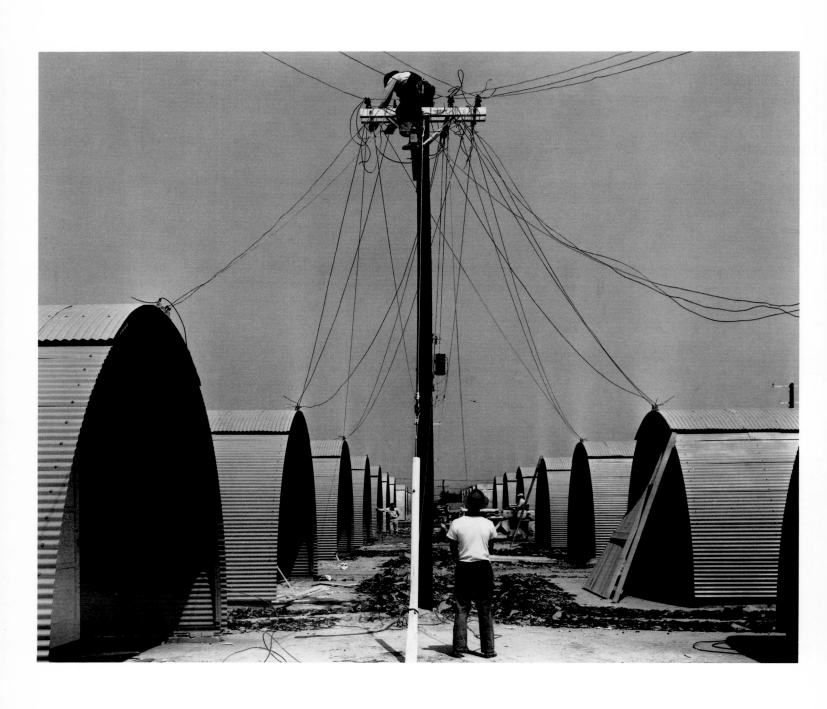

QUONSETT HUT HOUSING FOR VETERANS *Los Angeles 1947*

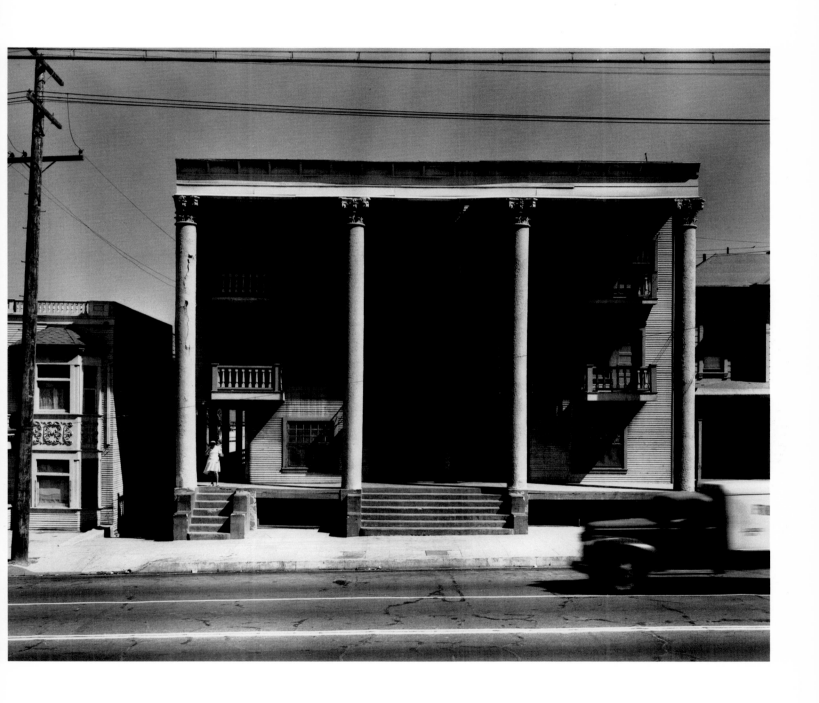

BUNKER HILL APARTMENT BUILDING *Los Angeles 1948 (where Music Center and theaters have since been built)*

I was photographing a row of tired wooden houses in the barrio when I heard a child cry. Louder than most, more persistent. The sound said, *"Where are you? Clean my bottom! Milk!"* I poked my head inside the window and saw him there on the stained mattress, under the plastic Jesus picture, bawling.

Invading people's privacy like that is a famous way to get killed. *Blam!* goes the shotgun in your face. Younger then and foolish, wanting the picture, I shoved my Speed Graphic through the window. The kid stopped yelling at once. He looked me in the eye right back through my camera finder. That's the moment of this photograph.

He isn't scared by my intrusion. He isn't sick or poorly fed. Solid body. Lungs like a football player. What he is, is surprised. What he'd been expecting was his mother, to give him love. So who is this weird stranger interferring with his act?

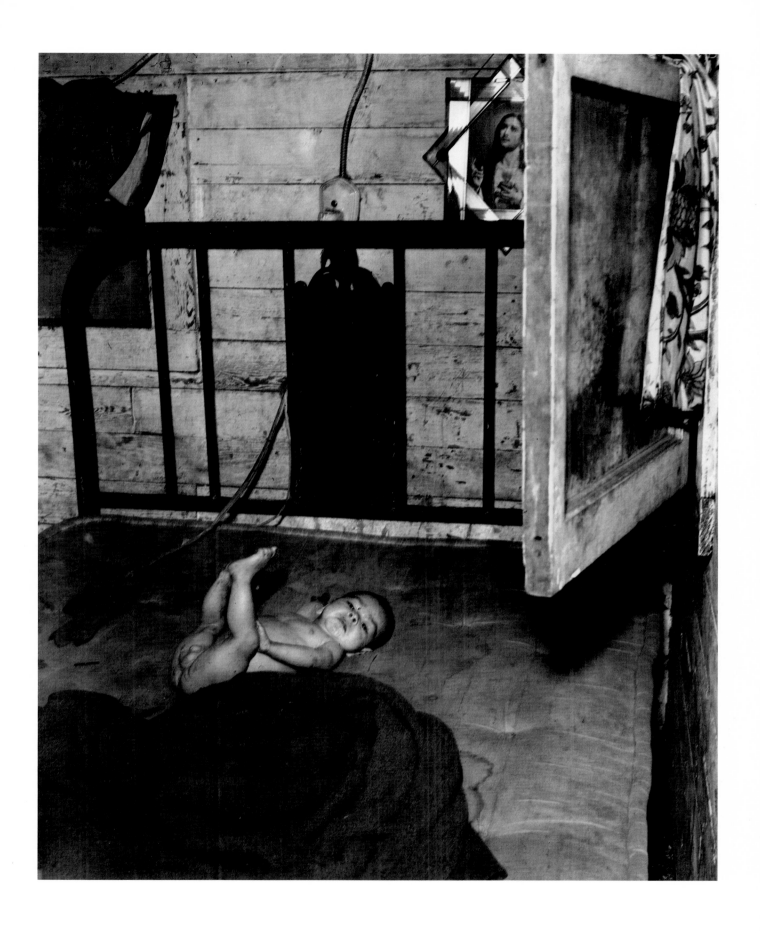

BABY/BED/JESUS *Los Angeles 1950*

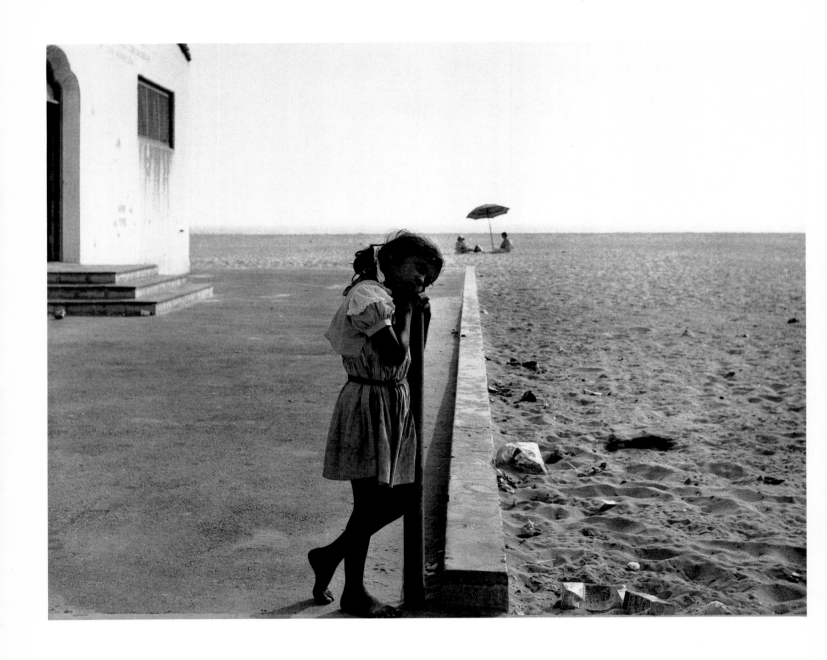

PENSIVE CHILD *Venice Beach 1952*

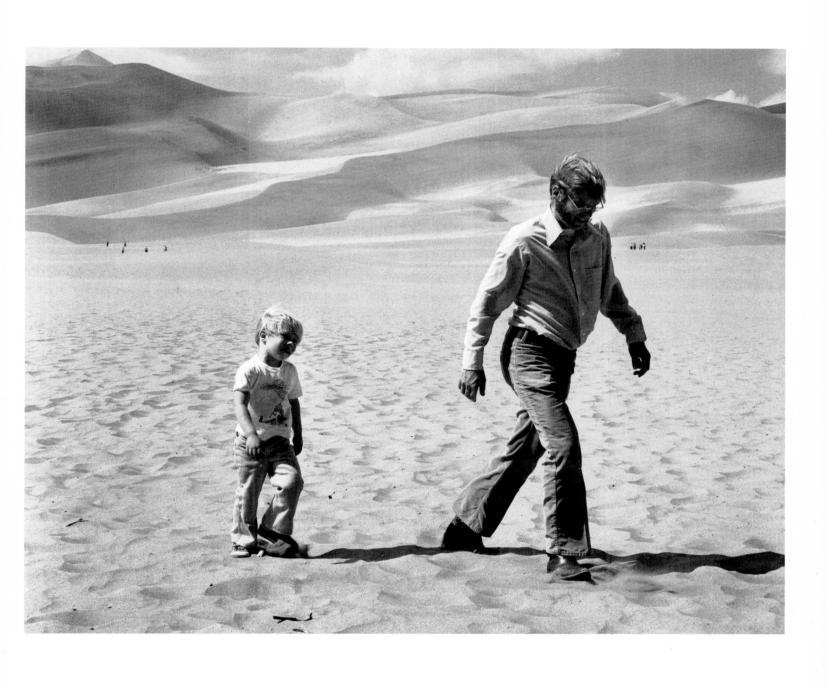

FATHER AND TIRED SON *White Sands National Monument, New Mexico 1978*

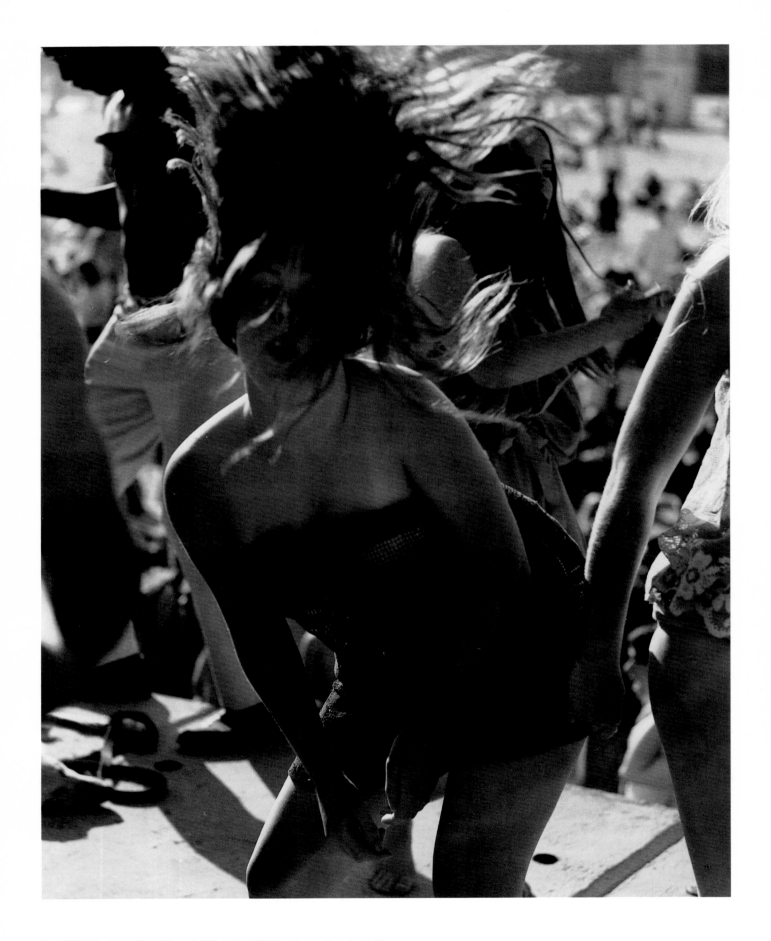

DANCERS, OUTDOOR ROCK CONCERT *Venice Beach 1967*

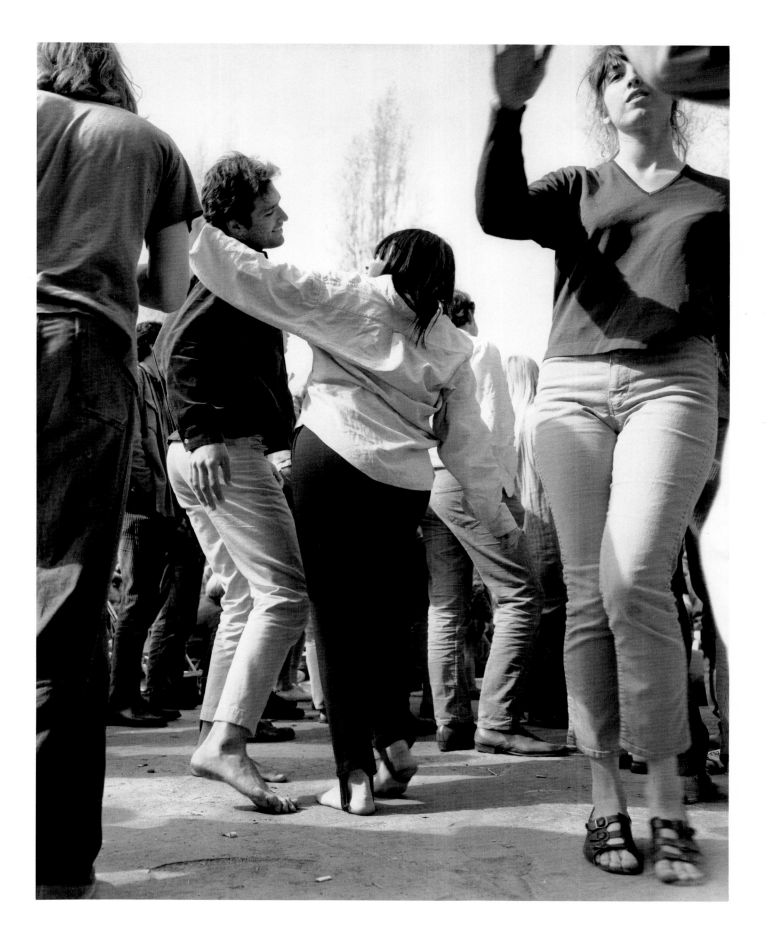

DANCERS, OUTDOOR ROCK CONCERT *Berkeley 1969*

I slept aboard Allan Watts' old houseboat and in the cold morning put on sweaters and walked down the dock in the fog.

What's that? During the night something impossible has crawled out of dreams and parked by the metal doors of a garage. *Imported Motors,* the sign says. From Mars?

It's a 1960's American sedan. Chevy maybe. Its exhaust pipes spit straw fire. Its body is wholly encrusted with an applique of toys and kitchen appliances, shoe soles and colored tiles, buttons, baby dolls, sea shells, papier mache fruit. A white horse gallops through the rear window. Mickey and Minnie Mouse are here, and Santa Claus. From the back seat Greta Garbo looks out serenely.

The Watts Towers of Simon Rodia come to mind. Heironymous Bosch. All honor for his masterpiece and years of work to the street artist!

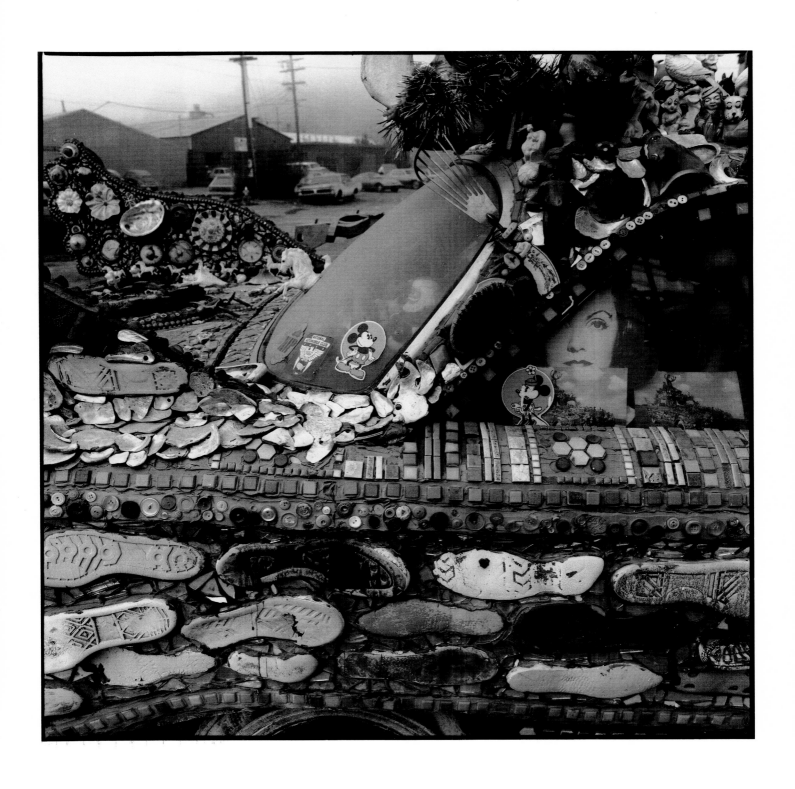

FANTASY CAR *Sausalito 1977*

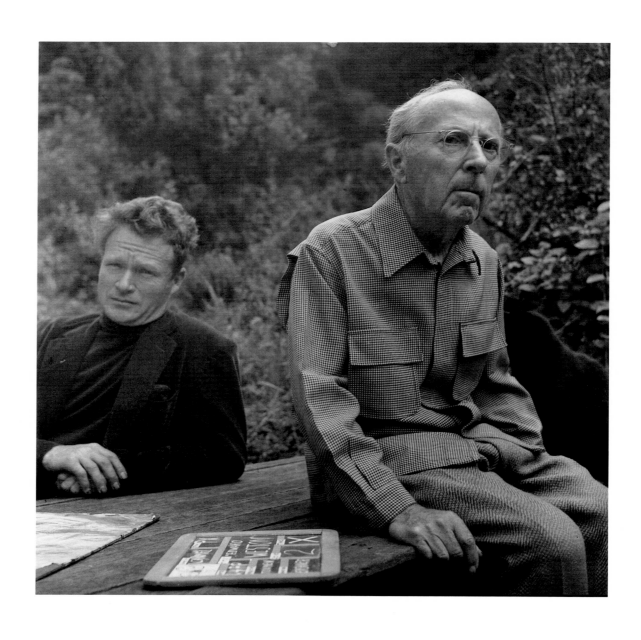

BRETT WESTON AND EDWARD WESTON *Carmel 1956 (during filming of "The Naked Eye")*

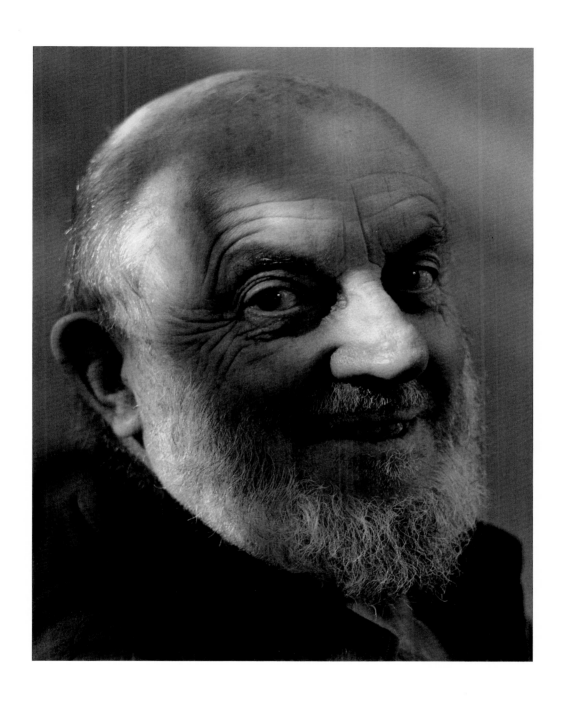

ANSEL ADAMS *Carmel 1979 (three days before his successful open-heart surgery)*

Light lets its mystery happen best at dawn and just before sunset.

This late afternoon moment in high mountains, the light was crystaline. The long shadows were hard and opaque. Ten feet over the deserted street stood a full-sized black horse.

A dog appears, black. I raise the camera, allow my own shadow to join the strangeness.

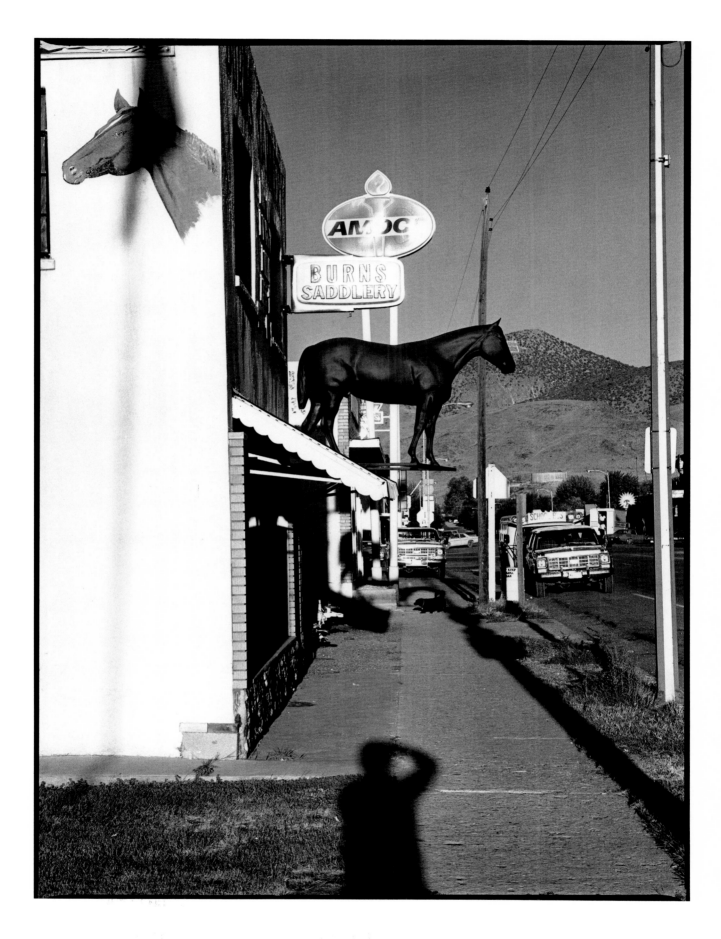

BLACK HORSE *Salida, Colorado 1978*

A cathedral is built to be beautiful. Chartres. St. Mark's. Ankor Wat. But a country chapel pattycaked up out of mud?

Somehow the handwork and unstraight lines of Ranchos de Taos have moved generations of Americans. Our artists have painted it, and photographed — O'Keefe, Sheeler, Strand, Adams.

In the flow of tourists with cameras, I watch the slow sun move over adobe walls. Textures modulate. Shadows change. Dusty Cadillacs park alongside the church, and leave. Toyotas. Buses full of children with ice cream. I think I will not dare photograph Ranchos de Taos. It's been done.

But suddenly in late afternoon all vehicles are gone except one school bus. A bank of clouds poses over the church. An old horse pulls a cart by, dropping biological gifts. When a nun and a young man with guitar case glide into view, I find I can no longer not make a photograph.

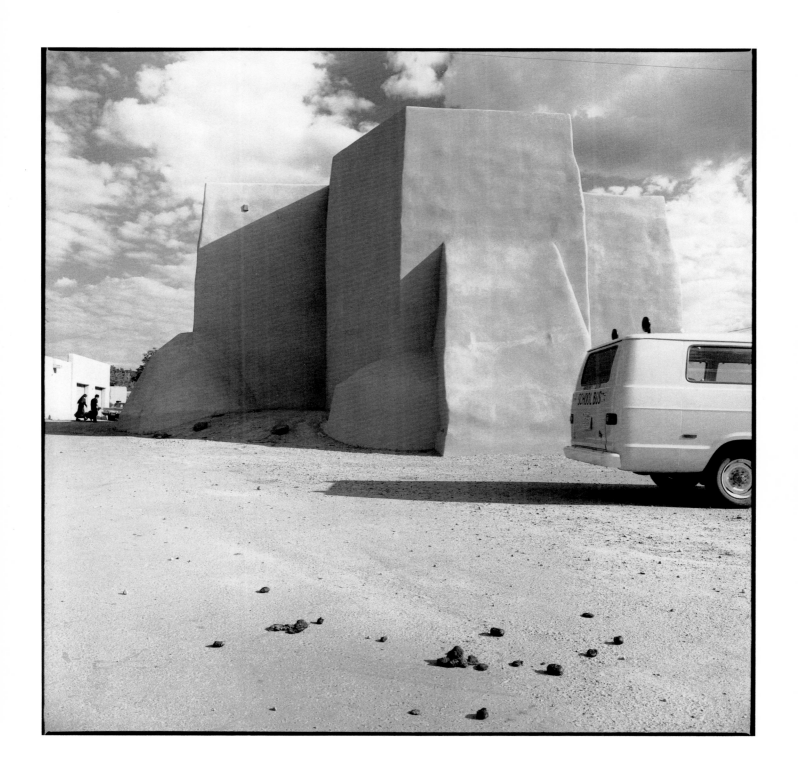

RANCHOS DE TAOS CHURCH *New Mexico 1977*

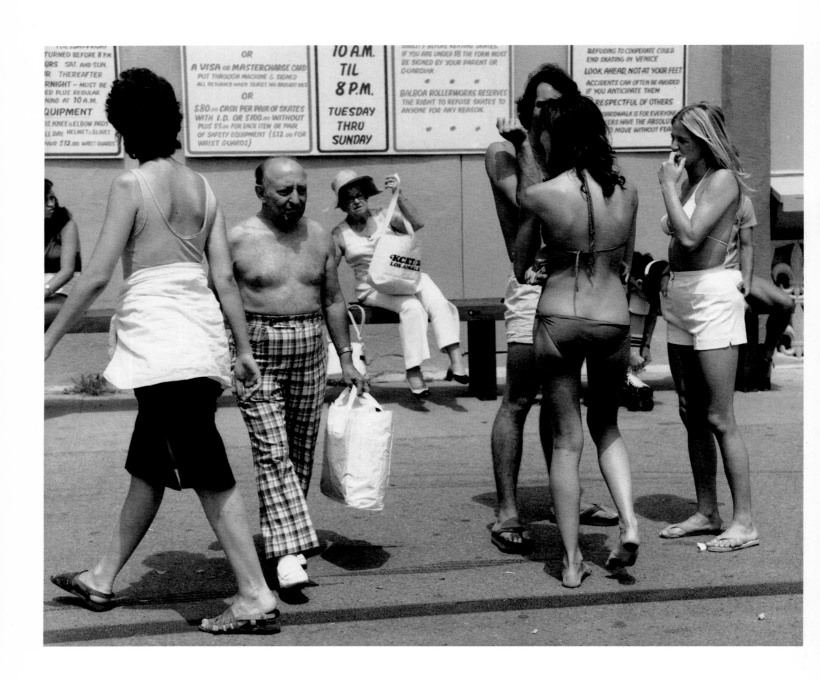

OCEAN WALK *Venice 1980*

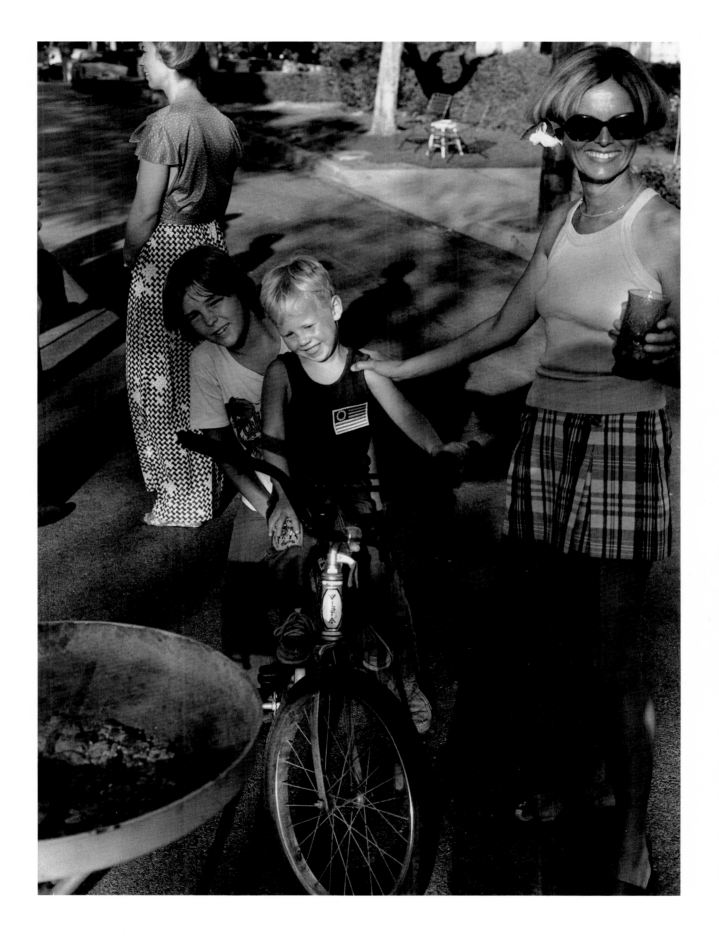

BICENTENNIAL BLOCK PARTY *Brentwood 1976*

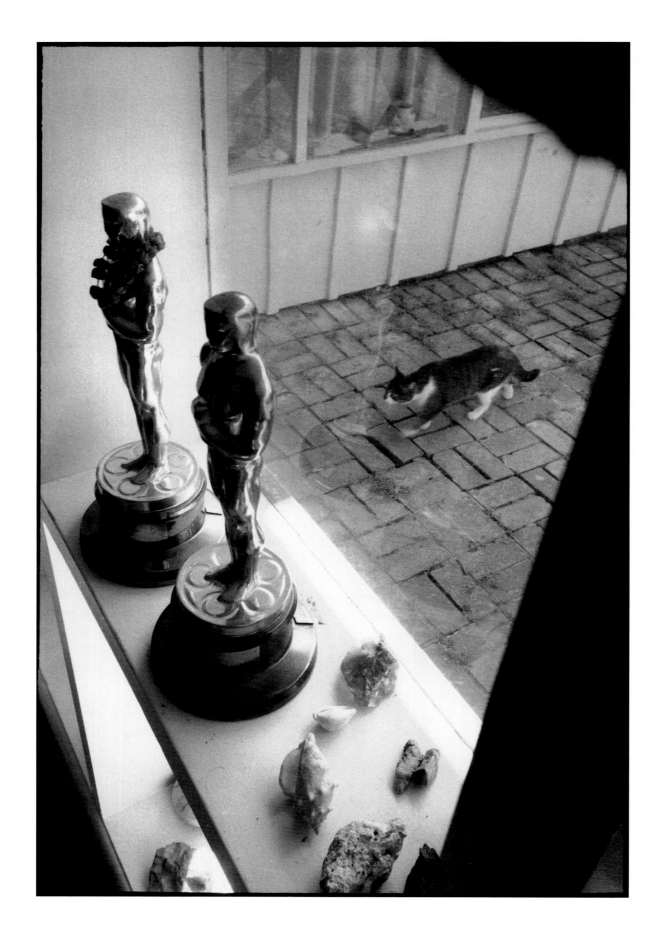

HOLLYWOOD WINDOW *1980*

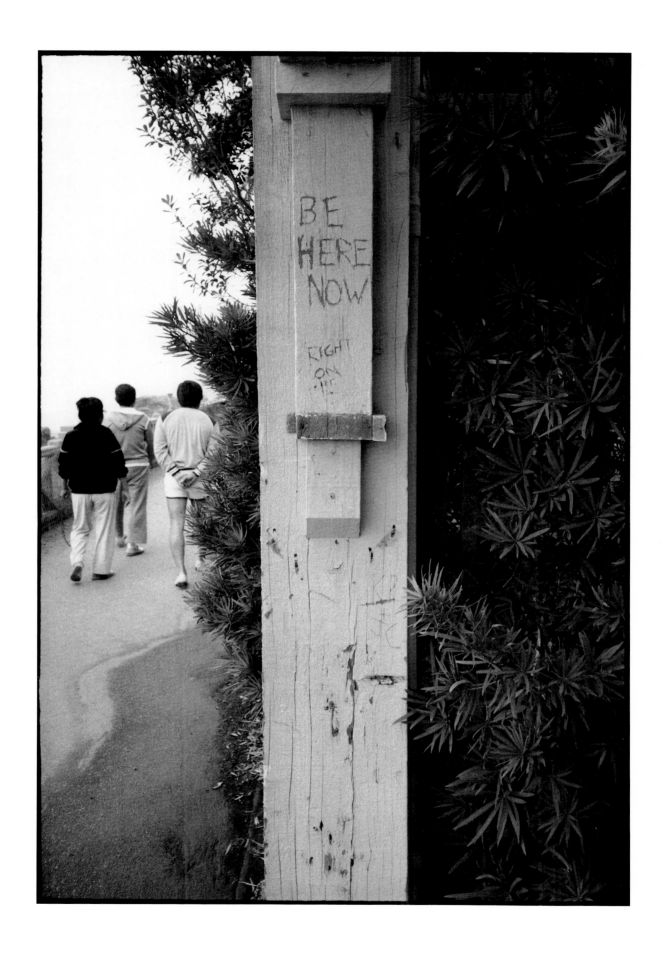

"BE HERE NOW" *Santa Monica 1980*

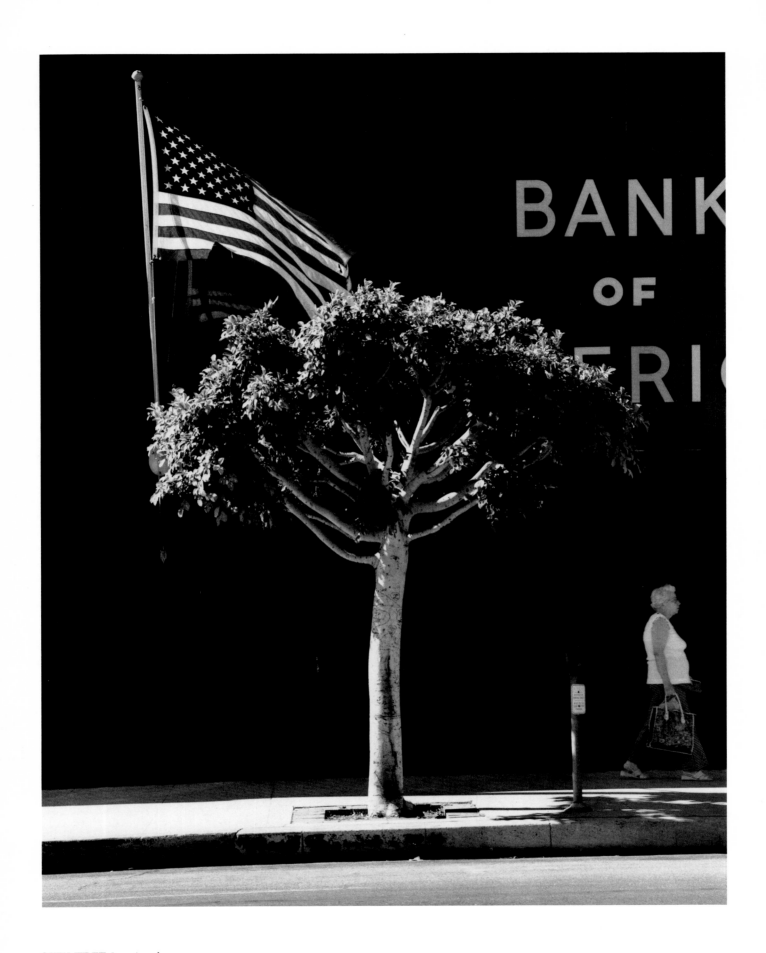

CITY TREE *Los Angeles*

MEXICO (1979)

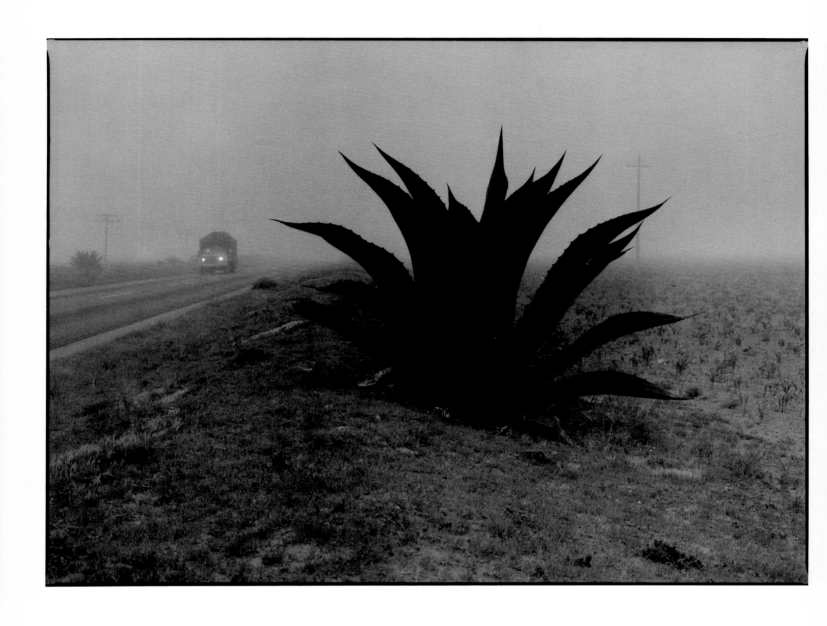

MAGUEY PLANT AND TRUCK, DAWN *(homage to Edward Weston)*

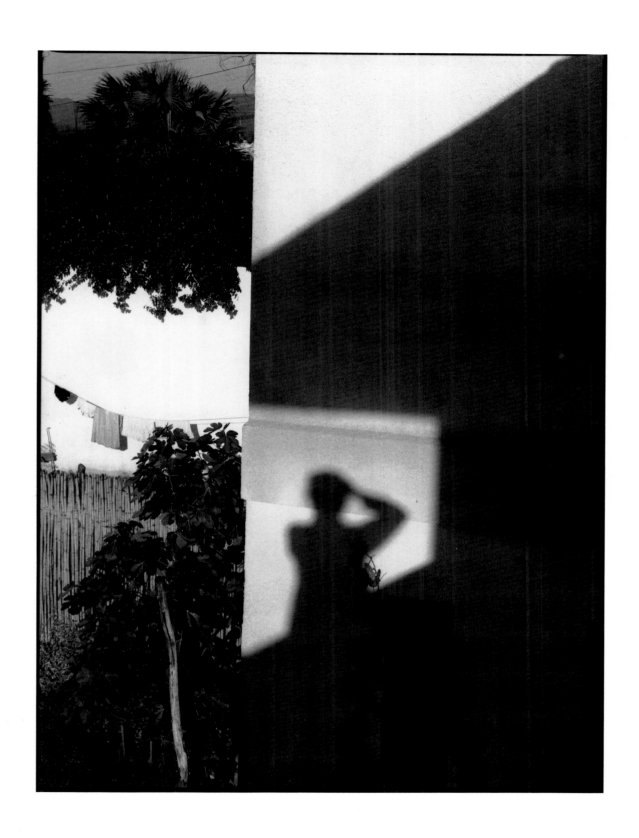

SUNRISE *Xalapa*

A cloud starts across the sky like the fist of an Aztec God. One cumulus cloud has filled and twisted, become a Thunderhead, bringing fierce winds, rivers of rain, darkness. I open my lens wide, make this picture as the first drops fall.

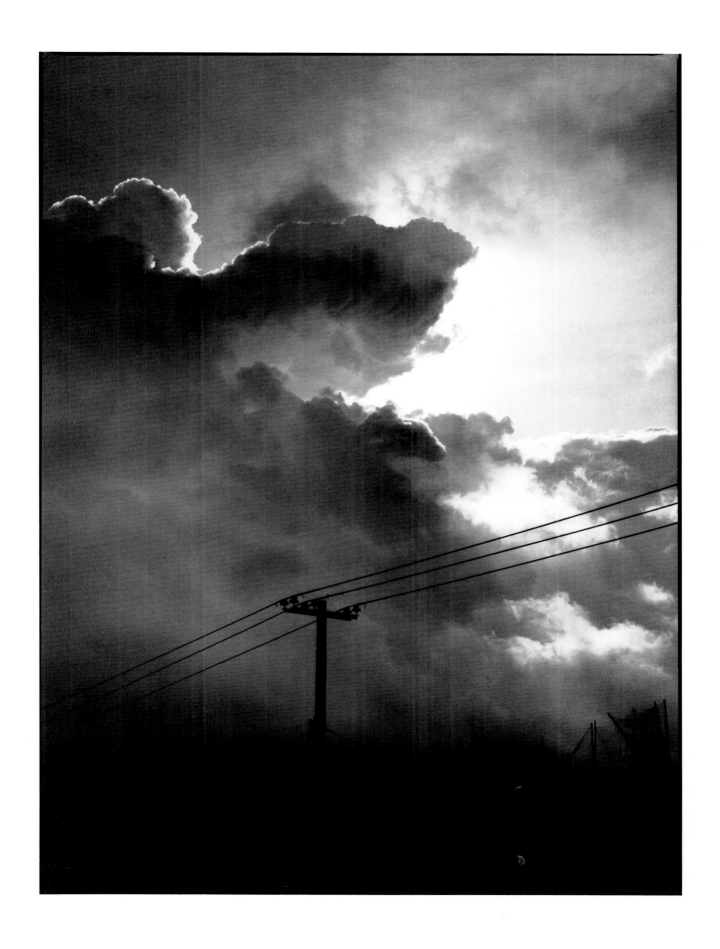

STORM *Xalapa*

Street photography is like playing chess. You have to figure the future, foresee moves. Except that in chess you can sit for twenty minutes and think.

Street events won't wait. It's now, instant choreography.

I see the black-and-whiteness of these dalmations lope down the old cobblestone street. I smell a picture. The dogs too stop to smell — bits of what? Entrails, outside the pig butcher's shop. He himself emerges. He eyes the dogs speculatively.

Now!

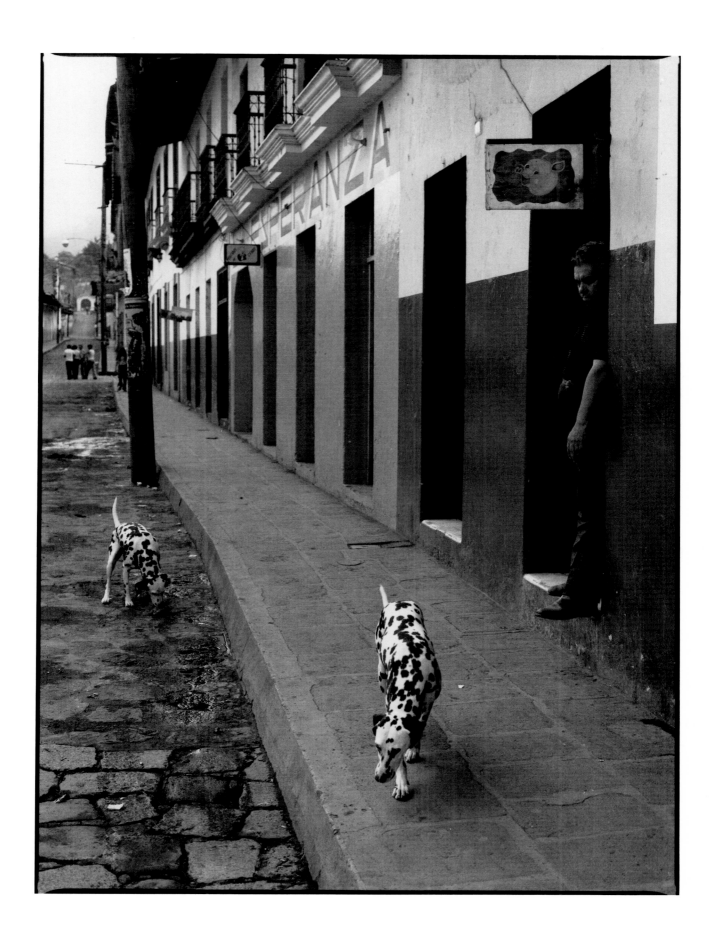

THE BUTCHER *Naolinco*

83

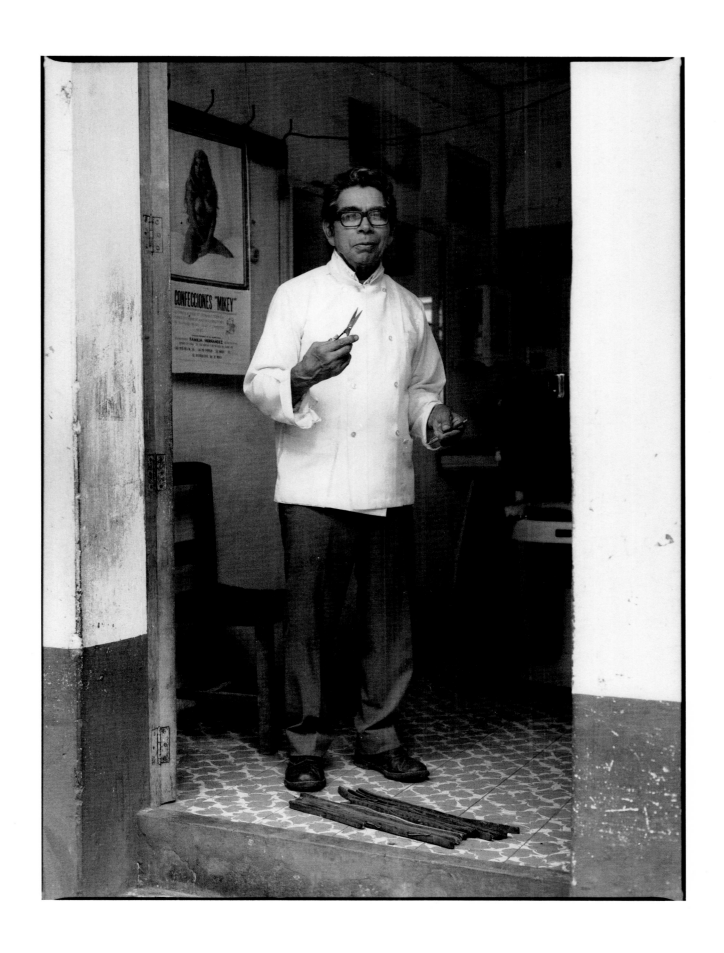

THE BARBER *Naolinco*

IN PRAISE OF WOMEN

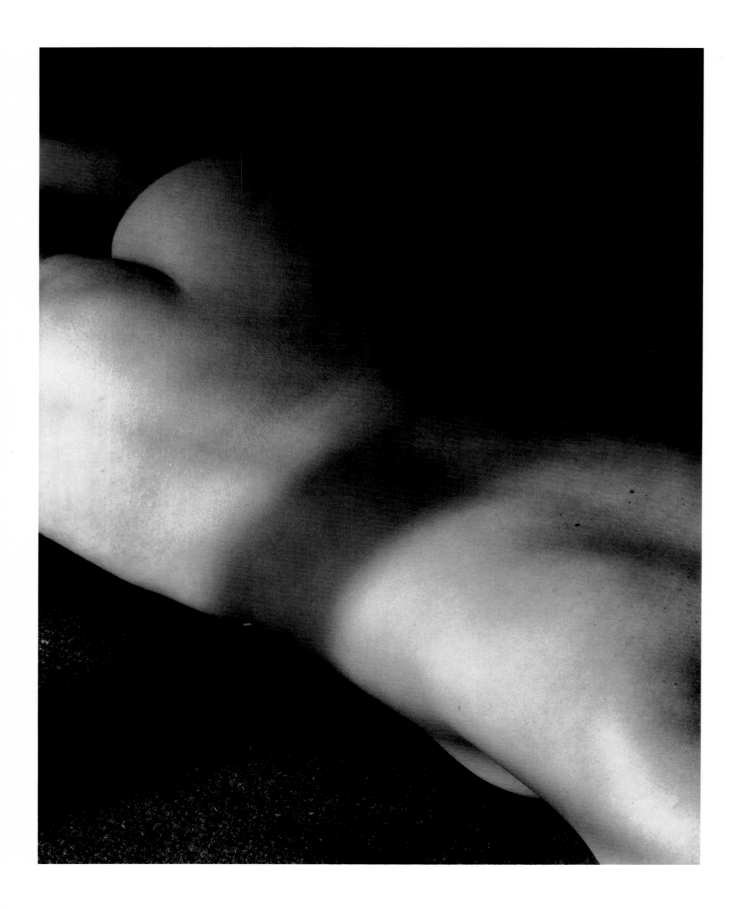

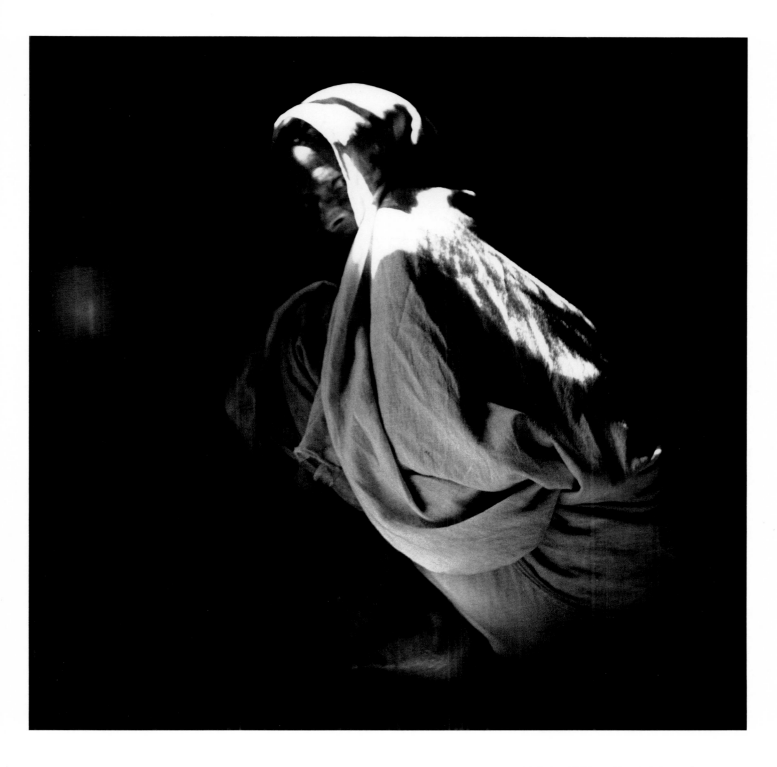

WOMAN IN HER KITCHEN *Calcutta 1945*

FIGURE *Los Angeles 1947*

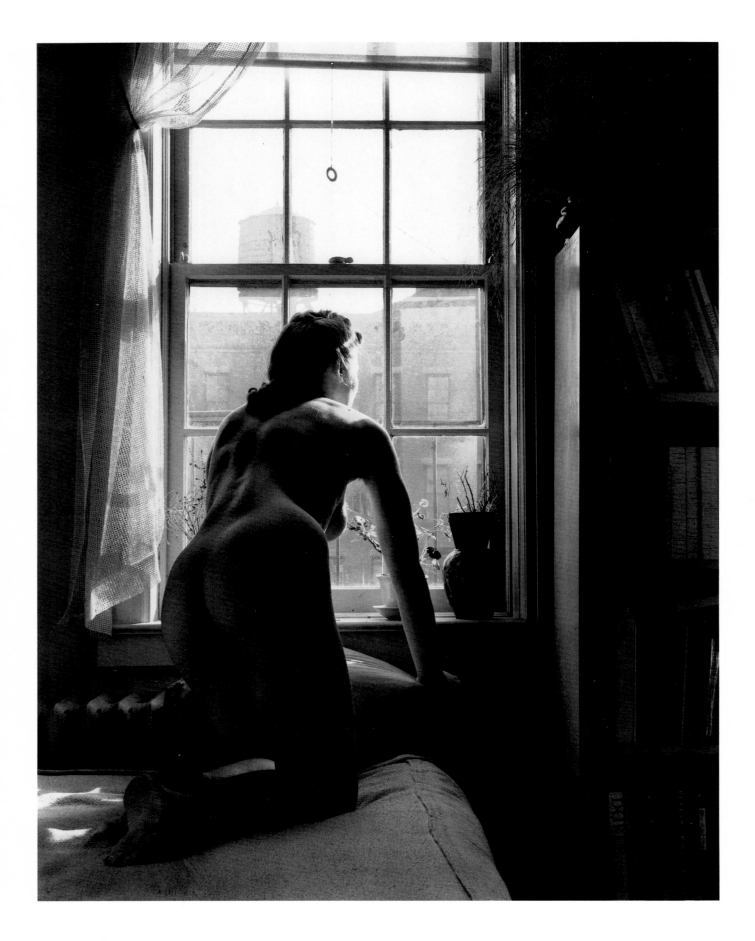

FIGURE *Brooklyn 1939*

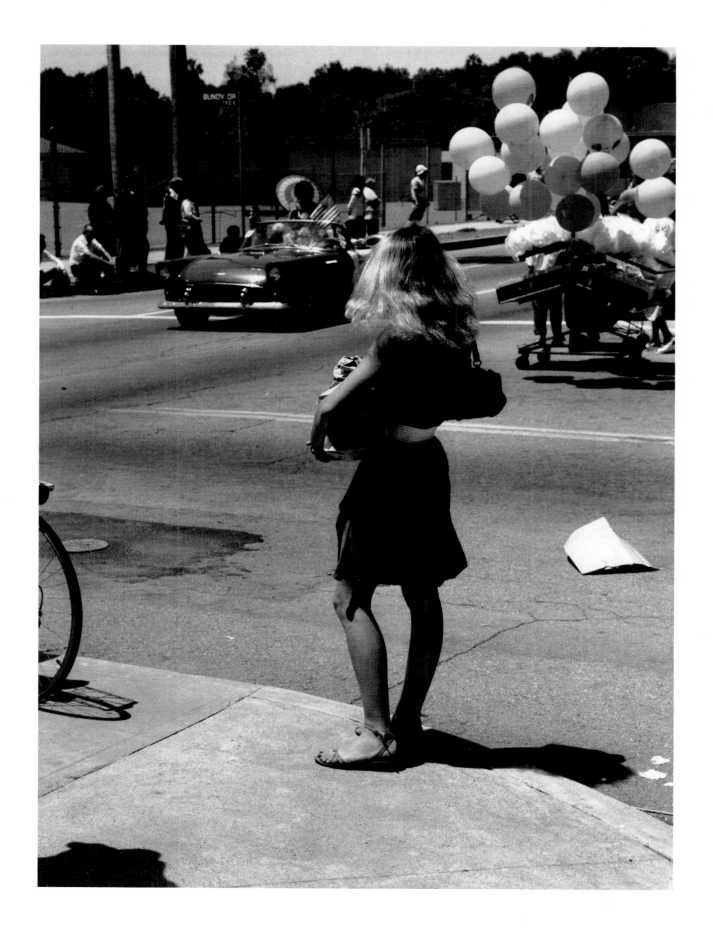

YOUNG WOMAN WITH PACKAGE *Los Angeles 1980*

My friends trusted me and my camera to watch
their tenderness. It was like being present at
the Creation.

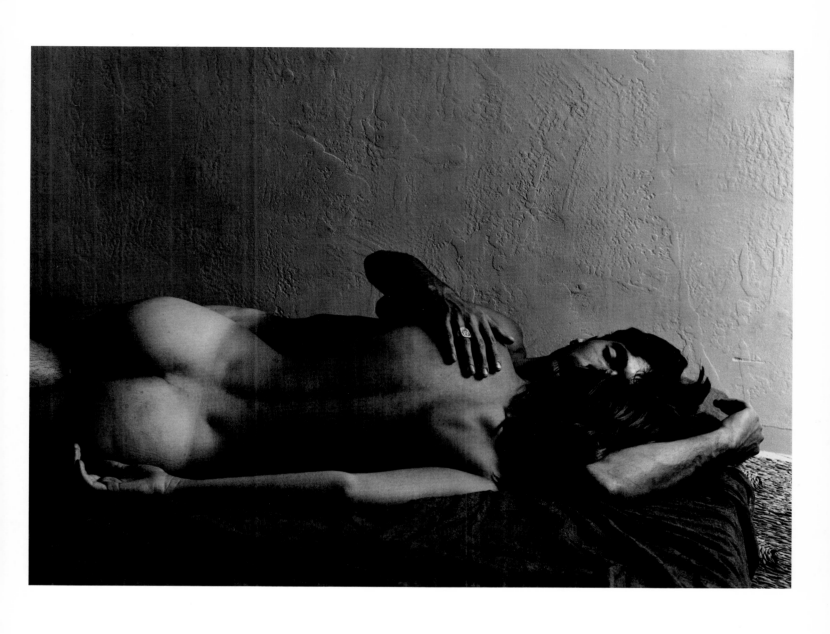

LOVERS *Berkeley 1969*

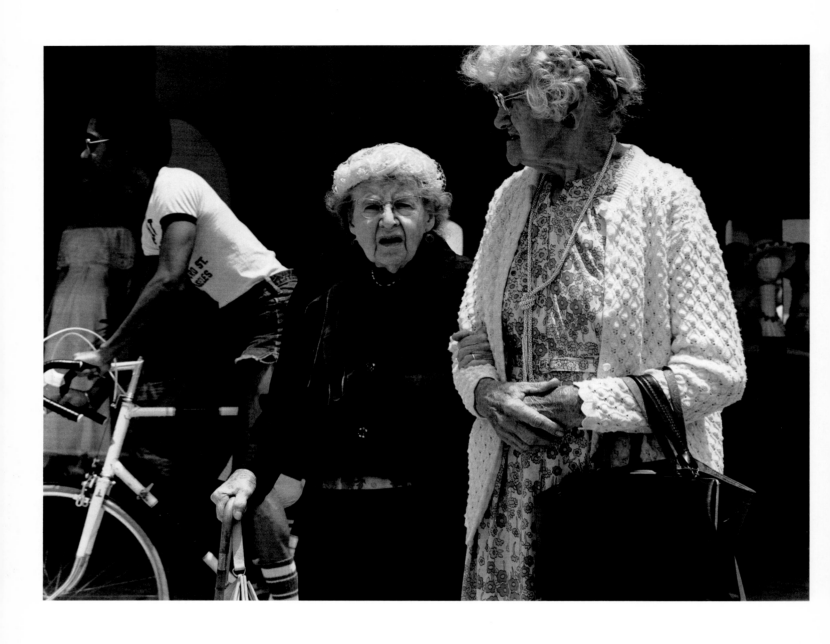

OLDER WOMEN *Los Angeles 1977 (Fairfax & Wilshire)*

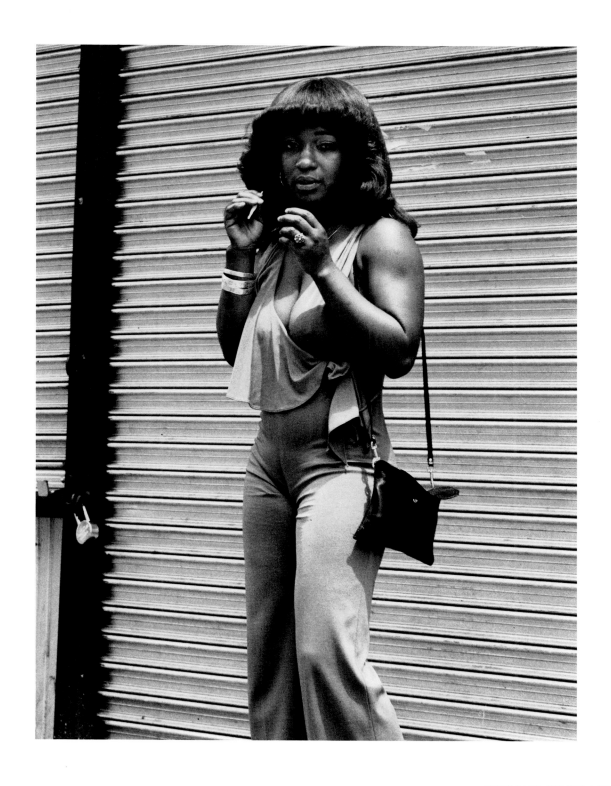

WOMAN, TIMES SQUARE *1979*

We have a brief one-sided conversation.
"Mothafuckah!" she says. I can't blame her. She
thinks I'm a cop or a narc.

"*Yes, I'll pose for you,*" she said. "*I'd like to see how I look to your camera.*". . . She steps toward the window, the light. Her fingers pause to touch the bed as her girl-woman body moves by.

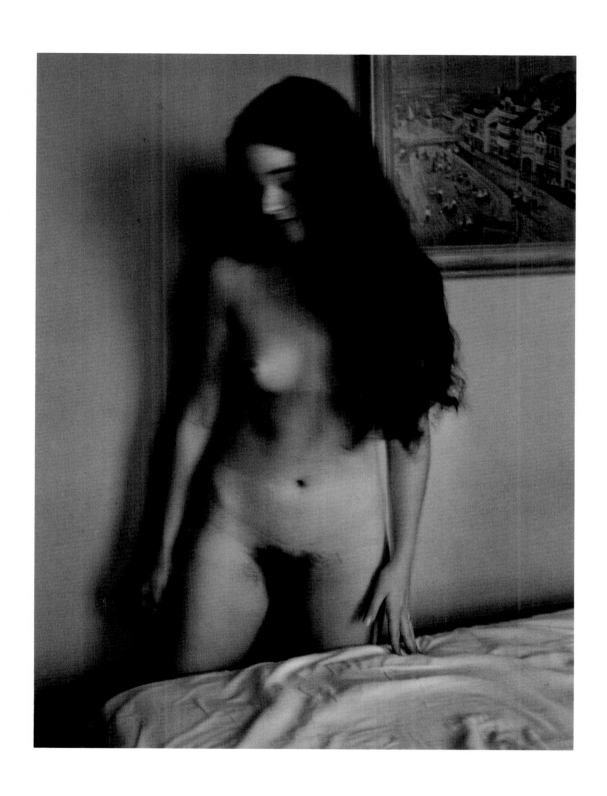

YOUNG WOMAN *New York 1965*

SWORN TESTIMONY OF A STREET PHOTOGRAPHER

At puberty I discovered photography and girls.

The photography happened when this kid with my name first looked into the ground glass of a reflex camera. I was hooked for life. The magic was that the image inside the camera seemed more urgent and vital than the "reality" in front of it, some trees. How could that be? I've spent the rest of my life finding out.

One reason seems to be that the camera frames a precise part of reality, separates it from chaotic space and time. That's steadying to us anxious human beings. The detail becomes known, significant, demonstrated.

A further answer is that photography dusts us with immortality. The camera stops time, freezes it into formed keepable memories.

I am a street photographer and have from boyhood obsessively photographed the people, events and light of everyday life. The ordinary has always seemed enough of a miracle. My calling as photographer has been to celebrate what is, and what could be. When the appropriate moment and form are found and an optimum print made, each photograph becomes sworn testimony. The body of work, as exemplified in this book, becomes a testament.

Technique is not a small matter. The way we do anything determines what it and we become. Craft requires some understanding and mastery of tools. Simplicity seems to be the key.

One camera is enough, and one lens. They can become organic extensions of your hand, eye and heart. Chemistry and materials can be minimal. One film, one paper and a clean darkroom bring concentration to the work.

I use only Eastman's fast Tri-X roll film and have always developed negatives in Eastman's D-76. I overexpose slightly and underdevelop, working for shadow detail and broad range of tones. I print by enlargement on Ilford papers, sometimes Agfa, and use a diffusion type enlarger, currently a big precise Durst.

After starting with amateur cameras, I worked for years — did all the Bethlehem and early Times

INDIAN ROCK CARVING *New Mexico 1956. Frame from "The Naked Eye," with superimposed image of sun.*

Square and Puerto Rico work — with a 3¼ x 4¼ Speed Graphic camera and an f4.5 Zeiss Tessar lens.

During the Second World War I switched to the 2¼x2¼ Rolleiflex, for portability and speed. I also carried a 2¼x2¼ Super Ikonta B, an eye-level camera safer to use when someone is shooting at you.

Lately I've supplemented my Rolleiflex (now the wide-angle model) with a Mimaya 645 and a Plaubel Makina II. All three cameras use #120 roll film. I also indulge in occasional Polaroid photography and keep a visual notebook using the compact 35mm Olympus XA. Some of the ways I handle a camera are discussed in the text of this book.

Around 1950 I was seduced by motion pictures. The Big Time! For fifteen years I photographed, wrote, directed, edited and/or produced more than 100 films, including classroom epics, a 26-part television series (*Winston Churchill — The Valiant Years*) and five independent 35mm features. My movies won two Academy Awards but didn't earn serious money since they were mostly documentaries. I did write some fiction for television. And I directed and co-produced one money-earning melodrama, *Operation Dames,* for American International. This was the heart-warming story of two USO showgirls caught behind enemy lines in Korea. American International offered me a contract to direct two more exploitation movies, which might likely have led to fame, riches and heart attack. I said no.

My one possible footnote in film history has to do with still photography. In *The True Story of the Civil War* (1956) I used no "motion" picture footage at all, only the still photographs of Matthew Brady & Co. I moved my camera into and across these images and cut and dissolved freely, as a movie director uses a live action scene. I recorded and edited live voices, sound effects and music in counterpoint to these "moving" pictures. The results seemed to me magical, a true time machine. Instead of watching actors in costume read lines in studio sets, the audience witnesses actual history through the eyes of men who were there.

I pioneered this technique, further developed it in *The Naked Eye* and *Black Fox,* and it has become a standard part of film and television language.

Teaching motion pictures at UCLA (where I learn more than I teach), I find that the insights and ways of still photography are useful for film students. Using the camera teaches how light works, how it can shape a face, a landscape, a movement, a meaning. Study of the history of photography teaches the range and possibilities of style.

In my own work, I brought back to still photography from cinema the concept of sound-image montage. When you creatively combine words (soundtrack) with pictures, you can end with a work more powerful than the sum of its parts. Movies! This works with stills too, and books.

Despite some purist editors and curators, a photograph on a page or wall sometimes has a way of just sitting there. A gallery or book full of such images can be cold and boring. Words alone on dense printed pages, to our modern media-attuned taste, often lack energy and appeal.

But words and photographs well brought together, not as captions or illustrations but in counterpoint, sometimes can transmute into a new creation. I call this form *the paper movie.* You now hold one in your hand. It's a form available to everyone. The family photo album with scrawled names, dates, endearments and wisecracks is prototype.

Lucille Bunin Askin, curator and art visionary, has faith in my work and has encouraged it. So have Lee Witkin, James Enyeart, Nettie Lipton, Cornell Capa, Frederick S. Wight, Jack Carter, Richard Gregg, Richard Redd, Ricardo Viera, G. Ray Hawkins, David Fahey, Joe Brubaker, Joan Sands, William Ewing, Robert Gray, Cecile Leneman and John Szarkowski.

David Gardner and Pat Smith are responsible for the presswork of this book and the uncanny faithfullness of its laser-scanned reproductions. Liza Kevin Hennessey, Sonoko Kondo, Nina Bisutti and Peter Michos helped put the book together. James Kubeck edited the manuscript with wisdom and grace.

My masters have been D.W. Griffith, Alfred Steiglitz, Aldous Huxley, Edward Weston, Walker Evans, Sid Grossman, Archibald MacLeish, Lawrence Lipton, Alain Resnais, Ansel Adams and Slavko Vorkapitch.

I try to be worthy of all these generous teachers and, like them, to do work useful to a large

audience (especially you). I try to learn enough craft, compassion and laughter to stop time occasionally — to manifest on photographic paper a few ordinary miracles.

A Brief Chronology

1917 Born Springtown, Pennsylvania.

1927 First photographs, with mother's "vest-pocket" Kodak.

1938 Exhibited six photographs, Lehigh University Art Gallery. Met Aldous Huxley.

1939 *Speech For the Young*, Bethlehem, Pa., self-published, 50 photographs and 20 poems.
Graduated Lehigh University, BA Fine Arts.
To New York, free-lance photography and journalism, six weeks study Photo League.

1940 Began self-assigned project to photograph Times Square.

1941 To Nova Scotia on photo assignment *(bed and board but no wages, they keep negatives!)*
To Puerto Rico photographer staff National Youth Administration.
Photo document on prostitution US Public Health Service.
First film *Tropico* (30 minutes 16mm) for NYA.

1942 Volunteered US Army, assigned managing editor *Caribbean Sentinel*.
Joined staff *Yank, the Army Weekly* in San Juan, highest rank staff-sergeant.

1943 Married Lini Moerkerk Fuhr, New York.
To Calcutta edition *Yank*.
Combat missions Burma and China.

1944 *Yank's Magic Carpet*, text and photographs, Calcutta, US Army, 100,000 copies sold in PXs.
Flew first B-29 raid against Japan.

1945 To San Francisco staff Armed Forces Radio.
Reported founding conference United Nations.
Wrote broadcasts about bombing Hiroshima.
Met Alfred Steiglitz.

1946 Daughter Toby born, Los Angeles.
Free-lance photography and writing.
Photographs for local and national magazines.

1947 Met Edward Weston, Ansel Adams.

1951 Cinematography, Arch Oboler's *Five*, feature for Columbia Pictures.
First fiction published, *The Blond Dog*, **Story Magazine** *(became TV production with Cornell Wilde).*

1952 Married Hannelore Hahn.
Daughter Tina born 1954.

1940s and 1950s Photographs exhibited group shows Museum of Modern Art NY, *In and Out Of Focus, Fifty Photographs, Family of Man.*
Graduate study University of Southern California under Slavko Vorkapich. Films, TV, photography.

1957 Wrote, directed, produced *The Naked Eye*, 71-minute 35mm film, with Edward Weston, Weegee, Alfred Eisenstadt and Raymond Massey, Academy Award nomination, Special Jury Award, Venice. *The True Story of The Civil War*, 35mm film, Academy Award, First Prize, Venice.

1963 *Black Fox*, 90-minute 35mm feature about Adolf Hitler, narrated by Marlene Dietrich, Academy Award.

1966 Joined faculty University of California, Los Angeles, Professor of Motion Pictures/Television.

1969 *Dream of Islands*, exhibition 120 photographs with text at UCLA Art Gallery (prototype "paper movie" form).

1975 *Can't Argue With Sunrise / A Paper Movie*, text and photographs, Celestial Arts, Millbrae, California.
Exhibition 70 photographs and text at International Center of Photography NY, Lehigh University Art Gallery, G. Ray Hawkins Gallery Los Angeles.

1977 Exhibition 80 photographs Witkin Gallery NY. Exhibition 72 photographs Friends of Photography, Carmel, illustrated small catalogue with critical essay by James L. Enyeart.
Times Square 1940 / A Paper Movie, limited edition portfolio, text and 18 original prints, jointly published Witkin Gallery NY and G. Ray Hawkins Gallery Los Angeles.

1980 *Forty Years / Lou Stoumen*, limited portfolio, text and 20 original 16 x 20 photographs, jointly published Witkin Gallery NY and G. Ray Hawkins Gallery Los Angeles.

ORDINARY MIRACLES
The Photography of Lou Stoumen

University of New Mexico Art Gallery (Albuquerque) and in other public and private collections.

Of the 115 photographs in this exhibition, 69 are reproduced in the accompanying book. All prints are from the collection of the artist except #114 which is on loan from the Witkin Gallery, New York.

CATALOGUE of an
exhibition for Allentown Art Museum, UCLA Frederick S. Wight Art Gallery, International Center of Photography and other institutions during 1981, 1982 and 1983.

All photographs were printed by the artist in black and white on gelatin-silver paper. Lou Stoumen works on standard size papers and prints are mostly 11" by 14" and 16" by 20", including archival white borders of one inch or more. Several of the early works are 8" x 10" or smaller, including borders. Many prints are vintage (made about the same time as the negative). A few are unique prints made from lost negatives. Later works are toned in selenium.

Examples and portfolios of Lou Stoumen's photographs are in the collections of Allentown Art Museum (Allentown, Pennsylvania), Camden Art Museum (Camden, Ohio), Center For Creative Photography (University of Arizona, Tucson), Museum of Fine Arts (Houston, Texas), Lehigh University Art Gallery (Bethlehem, Pennsylvania), Museum of Modern Art (New York), National Gallery of Canada (Ottowa), Frederick S. Wight Art Gallery (University of California, Los Angeles),

I HOMETOWN 1932-1939

1 Main Street, Bethlehem 1939
2 Airplane and Telephone Pole 1932
3 Girl On Pier, Saylor's Lake 1934
4 My Feet and Shoes, Saylor's Lake 1935
5 Woman With Prize Horse, Allentown County Fair 1935
6 Woman With Six Children, Allentown 1935
7 My Father's Oldsmobile After I Drove It Into The Tree In Front Of Charlie Schwab's House and Landed In St. Luke's Hospital With A Fractured Skull, 1934
8 The Children Of Jesus Goshya, Hellertown 1937
9 Student, Lehigh University 1940
10 Registrar Of Students, Lehigh University 1940
11 Freshman, Lehigh University 1940
12 Miss Bustin, Bethlehem 1940
13 Young Couple In Packard Convertible, Bethlehem 1939

II NEW YORK CITY 1937-1940

14 Collecting For Chinese Relief, Times Square 1937
15 Strike At Macy's 1937
16 Children Of Public School #34, The Bronx, Inside The Head Of Statue Of Liberty 1939
17 Sunrise, 43rd Street At Times Square 1940 *(homage to Alfred Steiglitz)*
18 Sunrise, Looking South From Times Square 1940
19 Going To Work, Morning 1940
20 Times Square In The Rain, 1940
21 Crowd Discusses War Bulletins Behind Times Building, Late Afternoon, 1940
22 Unemployed Warm Selves At Embers Of Packing Crate Fire 1940
23 Drafted US Army Soldiers Wait For Transportation On Pier, Battery 1939
24 Man Alone Listens To Salvation Army Lass, Times Square 1940
25 Excavation, Times Square 1940
26 Drunken Sailors, Times Square 1940

VIII IN PRAISE OF WOMEN

IX MISC.

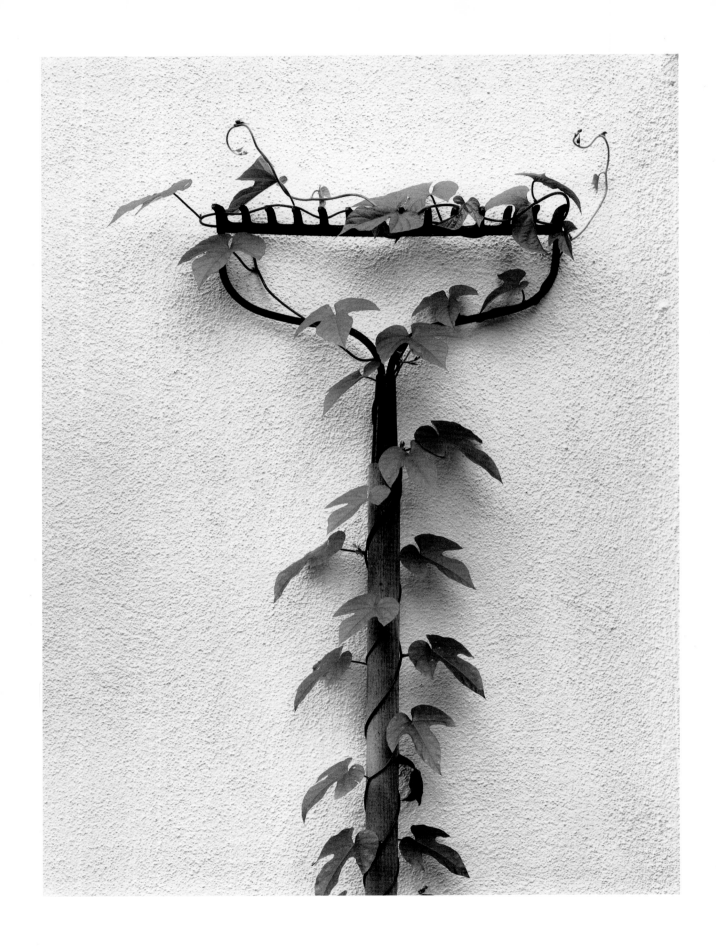

RAKE AND VINE *Los Angeles 1978*